University of California Press
Berkeley and Los Angeles, California

University of California Press, Ltd.
London, England

Published by arrangement with Lapis Press, San Francisco.
First University of California Press edition 1999.

Library of Congress Cataloging-in-Publication Data
O'Doherty, Brian
 Inside the white cube : the ideology of the gallery
space / Brian O'Doherty : introduction by Thomas McEvilley.
Expanded ed.
 p. cm.
 "The essays in this book originally appeared in Artforum
magazine in 1976 and 1986"—Copr. p.
 ISBN 978-0-520-22040-9 (paper : alk. paper)
 1. Space (Art) 2. Installations (Art) 3. Environment (Art)
I. Title.
N7430.7.036 1999
701' .8—dc21 99-42724
 CIP

Printed in Canada
12
11 10 9 8 7

The paper used in this publication meets the minimum
requirements of ANSI/NISO Z39.48-1992 (R 1997)
(Permanence of Paper).

Contents

For Barbara Novak

Acknowledgements

My thanks to John Coplans, who published the first three chapters in *Artforum* when he was editor, and to Charles Cowles, who was then the publisher. Ingrid Sischy, when she was *Artforum's* editor, published chapter IV and the Afterword. Jan Butterfield of the Lapis Press has been an ideal editor, and I am grateful to her for her determination to put these articles in book form. Barbara Novak read the text closely, as is her wont. Nancy Foote most kindly assembled the photographs. Susan Lively typed the text with precision and *brio*.

I am indebted to Jack Stauffacher for his careful design of the book.

I am also grateful to the museums and galleries which permitted the publication of the photographs which illustrate the text.

I want specially to thank Thomas McEvilley for so cogently setting the context in his introduction and Ann McCoy for suggesting the idea of the book to Lapis.

Mary Delmonico of the Whitney Museum has my gratitude for suggesting to my editor at the University of California Press, the most amiable James Clark, that the book be republished. I much appreciate Mari Coates's careful supervision of the expanded edition.

I should also thank Maurice Tuchman for his invitation to lecture at the Los Angeles County Museum of Art in January 1975, when the lecture "Inside the White Cube, 1855 – 1974" was first delivered.

Introduction

It has been the special genius of our century to investigate things in relation to their context, to come to see the context as formative on the thing, and, finally, to see the context as a thing itself. In this classic essay, first published as a series of three articles in *Artforum* in 1976, Brian O'Doherty discusses this turn toward context in twentieth century art. He investigates, perhaps for the first time, what the highly controlled context of the modernist gallery does to the art object, what it does to the viewing subject, and, in a crucial moment for modernism, how the context devours the object, becoming it.

In the first three sections, O'Doherty describes the modern gallery space as "constructed along laws as rigorous as those for building a medieval church." The basic principle behind these laws, he notes, is that "The outside world must not come in, so windows are usually sealed off. Walls are painted white. The ceiling becomes the source of light....The art is free, as the saying used to go, 'to take on its own life.'" The purpose of such a setting is not unlike the purpose of religious buildings – the artworks, like religious verities, are to appear "untouched by time and its vicissitudes." The condition of appearing out of time, or beyond time, implies a claim that the work already belongs to posterity – that is, it is an assurance of good investment. But it does strange things to the presentness of life, which, after all, unfolds itself in time. "Art exists in a kind of eternity of display, and though there is lots of 'period' (late modern) there is no time. This eternity gives the gallery a limbolike status; one has to have died already to be there."

In searching for the significance of this mode of exhibition one must look to other classes of chambers that have been constructed on similar principles. The roots of this chamber of eternal display are to be found not in the history of art so much as the history of religion, where they are in fact even more ancient than the medieval church. Egyptian tomb chambers, for example, provide an astonishingly close parallel. They too were designed to eliminate awareness of the outside world. They too were chambers where an illusion of eternal presence was to be protected from the flow of time. They too held paintings and sculptures that were regarded as magically contiguous with eternity and thus able to provide access to it or contact with it. Before the Egyptian tomb, functionally comparable spaces were the Paleolithic painted caves of the Magdalenian and Aurignacian ages in France and Spain. There, too, paintings and sculptures were found in a setting deliberately set off from the outside world and difficult of access – most of the famous cave galleries are nowhere near the entrances, and some of them require exacting climbing and spelunking to get to them.

Such ritual spaces are symbolic reestablishments of the ancient umbilicus which, in myths worldwide, once connected heaven and earth. The connection is renewed symbolically for the purposes of the tribe or, more specifically, of that caste or party in the tribe whose special interests are ritually represented. Since this is a space where access to higher metaphysical realms is made to seem available, it must be sheltered from the appearance of change and time. This specially segregated space is a kind of non-space, ultra-space, or ideal space where the surrounding matrix of space-time is symbolically annulled. In Paleolithic times the ultra-space filled with painting and sculpture seems to have served the ends of magical restitution to the biomass; afterlife beliefs and rituals may have been involved also. By Egyptian times these purposes had coalesced around the person of the Pharaoh: assurance of his afterlife through eternity was assurance of the sustenance of the state for which he stood. Behind these two purposes may be glimpsed the political interests of a class or ruling group attempting to consolidate its grip on power by seeking ratification from eternity. At one

level the process is a kind of sympathetic magic, an attempt to obtain something by ritually presenting something else that is in some way like the thing that is desired. If something like what one wants is present, the underlying reasoning implies, then what one wants may not be far behind. The construction of a supposedly unchanging space, then, or a space where the effects of change are deliberately disguised and hidden, is sympathetic magic to promote unchangingness in the real or non-ritual world; it is an attempt to cast an appearance of eternality over the status quo in terms of social values and also, in our modern instance, artistic values.

The eternity suggested in our exhibition spaces is ostensibly that of artistic posterity, of undying beauty, of the masterpiece. But in fact it is a specific sensibility, with specific limitations and conditionings, that is so glorified. By suggesting eternal ratification of a certain sensibility, the white cube suggests the eternal ratification of the claims of the caste or group sharing that sensibility. As a ritual place of meeting for members of that caste or group, it censors out the world of social variation, promoting a sense of the sole reality of its own point of view and, consequently, its endurance or eternal rightness. Seen thus, the endurance of a certain power structure is the end for which the sympathetic magic of the white cube is devised.

In the second of three sections of his essay, O'Doherty deals with the assumptions about human selfhood that are involved in the institutionalization of the white cube. "Presence before a work of art," he writes, "means that we absent ourselves in favor of the Eye and the Spectator." By the *Eye* he means the disembodied faculty that relates exclusively to formal visual means. The *Spectator* is the attenuated and bleached-out life of the self from which the Eye goes forth and which, in the meantime, does nothing else. The Eye and the Spectator are all that is left of someone who has "died," as O'Doherty puts it, by entering into the white cube. In return for the glimpse of ersatz eternity that the white cube affords us – and as a token of our solidarity with the special interests of a group – we give up our humanness and become the cardboard

Spectator with the disembodied Eye. For the sake of the intensity
of the separate and autonomous activity of the Eye we accept a
reduced level of life and self. In classical modernist galleries, as in
churches, one does not speak in a normal voice; one does not
laugh, eat, drink, lie down, or sleep; one does not get ill, go mad,
sing, dance, or make love. Indeed, since the white cube promotes
the myth that we are there essentially as spiritual beings – the Eye
is the *Eye of the Soul* – we are to be understood as tireless and above
the vicissitudes of chance and change. This slender and reduced
form of life is the type of behavior traditionally required in reli-
gious sanctuaries, where what is important is the repression of
individual interests in favor of the interests of the group. The essen-
tially religious nature of the white cube is most forcefully ex-
pressed by what it does to the humanness of anyone who enters it
and cooperates with its premises. On the Athenian Acropolis in
Plato's day one did not eat, drink, speak, laugh, and so on.

O'Doherty brilliantly traces the development of the white cube
out of the tradition of Western easel painting. He then redirects
attention to the same developments from another point of view,
that of the anti-formalist tradition represented here by Duchamp's
installations *1,200 Coal Bags* (1938) and *Mile of String* (1942),
which stepped once and for all outside the frame of the painting
and made the gallery space itself the primary material to be altered
by art. When O'Doherty recommends these works by Duchamp to
the attention of artists of the seventies he implies that not a great
deal has been achieved in the last forty or fifty years in breaking
down the barriers of disinterest or disdain that separate the two
traditions. Such lack of communication is impressive, since artists
themselves have attempted to carry on this dialogue for a genera-
tion. Yves Klein, for example, exhibited an empty gallery called
"The Void" (*Le vide*) (1958); shortly thereafter Arman responded
with an exhibition called "The Full" (*Le plein*) (1960) in which he
dialecticized Klein's positing of a transcendental space that is in
the world but not of it by filling the same gallery from floor to ceil-
ing and wall to wall with garbage. Michael Asher, James Lee Byars,
and others have used the empty exhibition space itself as their

primary material in various works – not to mention the tradition known as Light and Space. O'Doherty discovered the way to verbalize these developments for the first time. His essay is an example of criticism attempting to digest and analyze the recent past and the present – or shall I say the recent present. He argues that the communal mind of our culture went through a significant shift that expressed itself in the prominence of the white cube as a central material and expressive mode for art, as well as a fashionable style of displaying it. He identifies the transition in question as modernism bringing "to an endpoint its relentless habit of self-definition." The defining of self means the purposeful neglect of all that is other than self. It is a process increasingly reductive that finally leaves the slate wiped clean.

The white cube was a transitional device that attempted to bleach out the past and at the same time control the future by appealing to supposedly transcendental modes of presence and power. But the problem with transcendental principles is that by definition they speak of another world, not this one. It is this other world, or access to it, that the white cube represents. It is like Plato's vision of a higher metaphysical realm where form, shiningly attenuated and abstract like mathematics, is utterly disconnected from the life of human experience here below. (Pure form would exist, Plato felt, even if this world did not.) It is little recognized how much this aspect of Platonism has to do with modernist ways of thinking, and especially as a hidden controlling structure behind modernist esthetics. Revived in part as a compensatory reaction to the decline of religion, and promoted, however mistakenly, by our culture's attention to the unchanging abstraction of mathematics, the idea of pure form dominated the esthetics (and ethics) from which the white cube emerged. The Pythagoreans of Plato's day, including Plato himself, held that the beginning was a blank where there appeared inexplicably a spot which stretched into a line, which flowed into a plane, which folded into a solid, which cast a shadow, which is what we see. This set of elements – point, line, surface, solid, simulacrum – conceived as contentless except in their own-nature, is the primary equipment of much

modern art. The white cube represents the blank ultimate face of light from which, in the Platonic myth, these elements unspeakably evolve. In such types of thought, primary shapes and geometric abstractions are regarded as alive – in fact, as more intensely alive than anything with a specific content. The white cube's ultimate meaning is this life-erasing transcendental ambition disguised and converted to specific social purposes. O'Doherty's essays in this book are defenses of the real life of the world against the sterilized operating room of the white cube – defenses of time and change against the myth of the eternality and transcendence of pure form. In fact, they embody this defense as much as they express it. They are a kind of spooky reminder of time, illustrating how quickly the newest realizations of today become the classical insights of yesterday. Though it is common to say that modernism, with its exacerbated rate of change or development, is over, that rate of change not only remains but is increasing. Articles written today will, by 1990, either have been forgotten or like these, will have become classic.

<div style="text-align: right">

Thomas McEvilley
New York City 1986

</div>

I. Notes on the Gallery Space

A recurrent scene in sci-fi movies shows the earth withdrawing from the spacecraft until it becomes a horizon, a beachball, a grapefruit, a golf ball, a star. With the changes in scale, responses slide from the particular to the general. The individual is replaced by the race and we are a pushover for the race – a mortal biped, or tangle of them spread out below like a rug. From a certain height people are generally good. Vertical distance encourages this generosity. Horizontality doesn't seem to have the same moral virtue. Faraway figures may be approaching and we anticipate the insecurities of encounter. Life is horizontal, just one thing after another, a conveyer belt shuffling us toward the horizon. But history, the view from the departing spacecraft, is different. As the scale changes, layers of time are superimposed and through them we project perspectives with which to recover and correct the past. No wonder art gets bollixed up in this process; its history, perceived through time, is confounded by the picture in front of your eyes, a witness ready to change testimony at the slightest perceptual provocation. History and the eye have a profound wrangle at the center of this "constant" we call tradition.

All of us are now sure that the glut of history, rumor, and evidence we call the modernist tradition is being circumscribed by a horizon. Looking down, we see more clearly its "laws" of progress, its armature hammered out of idealist philosophy, its military metaphors of advance and conquest. What a sight it is – or was! Deployed ideologies, transcendent rockets, romantic slums where degradation and idealism obsessively couple, all those troops run-

ning back and forth in conventional wars. The campaign reports that end up pressed between boards on coffee tables give us little idea of the actual heroics. Those paradoxical achievements huddle down there, awaiting the revisions that will add the avant-garde era to tradition, or, as we sometimes fear, end it. Indeed, tradition itself, as the spacecraft withdraws, looks like another piece of bric-a-brac on the coffee table – no more than a kinetic assemblage glued together with reproductions, powered by little mythic motors and sporting tiny models of museums. And in its midst, one notices an evenly lighted "cell" that appears crucial to making the thing work: the gallery space.

The history of modernism is intimately framed by that space; or rather the history of modern art can be correlated with changes in that space and in the way we see it. We have now reached a point where we see not the art but the *space* first. (A cliché of the age is to ejaculate over the space on entering a gallery.) An image comes to mind of a white, ideal space that, more than any single picture, may be the archetypal image of twentieth century art; it clarifies itself through a process of historical inevitability usually attached to the art it contains.

The ideal gallery subtracts from the artwork all cues that interfere with the fact that it is "art." The work is isolated from everything that would detract from its own evaluation of itself. This gives the space a presence possessed by other spaces where conventions are preserved through the repetition of a closed system of values. Some of the sanctity of the church, the formality of the courtroom, the mystique of the experimental laboratory joins with chic design to produce a unique chamber of esthetics. So powerful are the perceptual fields of force within this chamber that, once outside it, art can lapse into secular status. Conversely, things become art in a space where powerful ideas about art focus on them. Indeed, the object frequently becomes the medium through which these ideas are manifested and proffered for discussion – a popular form of late modernist academicism ("ideas are more interesting than art"). The sacramental nature of the space becomes clear, and so does one of the great projective laws of modernism:

14

As modernism gets older, context becomes content. In a peculiar reversal, the object introduced into the gallery "frames" the gallery and its laws.

A gallery is constructed along laws as rigorous as those for building a medieval church. The outside world must not come in, so windows are usually sealed off. Walls are painted white. The ceiling becomes the source of light. The wooden floor is polished so that you click along clinically, or carpeted so that you pad soundlessly, resting the feet while the eyes have at the wall. The art is free, as the saying used to go, "to take on its own life." The discreet desk may be the only piece of furniture. In this context a standing ashtray becomes almost a sacred object, just as the firehose in a modern museum looks not like a firehose but an esthetic conundrum. Modernism's transposition of perception from life to formal values is complete. This, of course, is one of modernism's fatal diseases.

Unshadowed, white, clean, artificial – the space is devoted to the technology of esthetics. Works of art are mounted, hung, scattered for study. Their ungrubby surfaces are untouched by time and its vicissitudes. Art exists in a kind of eternity of display, and though there is lots of "period' (late modern), there is no time. This eternity gives the gallery a limbolike status; one has to have died already to be there. Indeed the presence of that odd piece of furniture, your own body, seems superfluous, an intrusion. The space offers the thought that while eyes and minds are welcome, space-occupying bodies are not – or are tolerated only as kinesthetic mannequins for further study. This Cartesian paradox is reinforced by one of the icons of our visual culture: the installation shot, *sans* figures. Here at last the spectator, oneself, is eliminated. You are there without being there – one of the major services provided for art by its old antagonist, photography. The installation shot is a metaphor for the gallery space. In it an ideal is fulfilled as strongly as in a Salon painting in the 1830s.

Indeed, the Salon itself implicitly defines what a gallery is, a definition appropriate for the esthetics of the period. A gallery is a place with a wall, which is covered with a wall of pictures. The

wall itself has no intrinsic esthetic; it is simply a necessity for an upright animal. Samuel F.B. Morse's *Exhibition Gallery at the Louvre* (1833) is upsetting to the modern eye: masterpieces as wallpaper, each one not yet separated out and isolated in space like a throne. Disregarding the (to us) horrid concatenation of periods and styles, the demands made on the spectator by the hanging pass our understanding. Are you to hire stilts to rise to the ceiling or get on hands and knees to sniff anything below the dado? Both high and low are underprivileged areas. You overhear a lot of complaints from artists about being "skied" but nothing about being "floored." Near the floor, pictures were at least accessible and could accommodate the connoisseur's "near" look before he withdrew to a more judicious distance. One can see the nineteenth century audience strolling, peering up, sticking their faces in pictures and falling into interrogative groups a proper distance away, pointing with a cane, perambulating again, clocking off the exhibition picture by picture. Larger paintings rise to the top (easier to see from a distance) and are sometimes tilted out from the wall to maintain the viewer's plane; the "best" pictures stay in the middle zone; small pictures drop to the bottom. The perfect hanging job is an ingenious mosaic of frames without a patch of wasted wall showing.

What perceptual law could justify (to our eyes) such a barbarity? One and one only: Each picture was seen as a self-contained entity, totally isolated from its slum-close neighbor by a heavy frame around and a complete perspective system within. Space was discontinuous and categorizable, just as the houses in which these pictures hung had different rooms for different functions. The nineteenth century mind was taxonomic, and the nineteenth century eye recognized hierarchies of genre and the authority of the frame.

How did the easel picture become such a neatly wrapped parcel of space? The discovery of perspective coincides with the rise of the easel picture, and the easel picture, in turn, confirms the promise of illusionism inherent in painting. There is a peculiar relationship between a mural – painted directly on the wall – and a picture

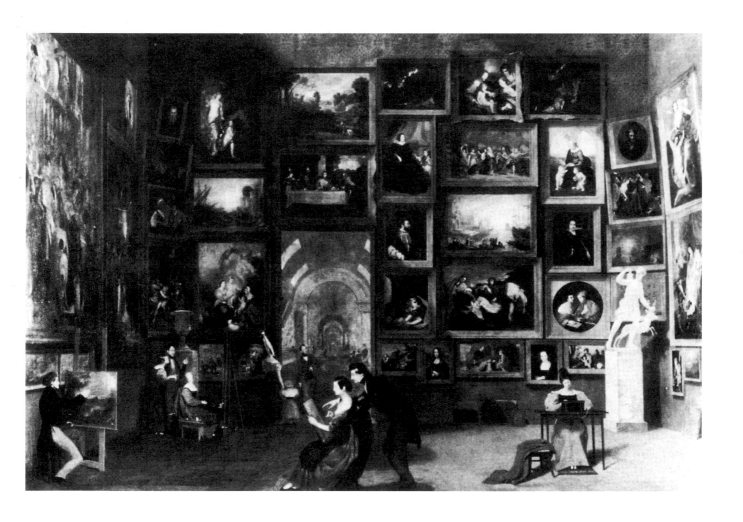

Samuel F.B. Morse, *Exhibition Gallery at the Louvre*, 1832 - 33,
courtesy Terra Museum of American Art, Evanston, Illinois.

that hangs on a wall; a painted wall is replaced by a piece of portable wall. Limits are established and framed; miniaturization becomes a powerful convention that assists rather than contradicts illusion. The space in murals tends to be shallow; even when illusion is an intrinsic part of the idea, the integrity of the wall is as often reinforced, by struts of painted architecture, as denied. The wall itself is always recognized as limiting depth (you don't walk through it), just as corners and ceilings (often in a variety of inventive ways) limit size. Close up, murals tend to be frank about their means – illusionism breaks down in a babble of method. You feel you are looking at the underpainting and often can't quite find your "place." Indeed, murals project ambiguous and wandering vectors with which the spectator attempts to align himself. The easel picture on the wall quickly indicates to him exactly where he stands.

For the easel picture is like a portable window that, once set on the wall, penetrates it with deep space. This theme is endlessly repeated in northern art, where a window within the picture in turn frames not only a further distance but confirms the window-like limits of the frame. The magical, boxlike status of some smaller easel pictures is due to the immense distances they contain and the perfect details they sustain on close examination. The frame of the easel picture is as much a psychological container for the artist as the room in which the viewer stands is for him or her. The perspective positions everything within the picture along a cone of space, against which the frame acts like a grid, echoing those cuts of foreground, middleground, and distance within. One "steps" firmly into such a picture or glides effortlessly, depending on its tonality and color. The greater the illusion, the greater the invitation to the spectator's eye. The eye is abstracted from an anchored body and projected as a miniature proxy into the picture to inhabit and test the articulations of its space.

For this process, the stability of the frame is as necessary as an oxygen tank is to a diver. Its limiting security completely defines the experience within. The border as absolute limit is confirmed in easel art up to the nineteenth century. Where it curtails or elides

subject matter, it does so in a way that strengthens the edge. The classic package of perspective enclosed by the Beaux-Arts frame makes it possible for pictures to hang like sardines. There is no suggestion that the space within the picture is continuous with the space on either side of it.

This suggestion is made only sporadically through the eighteenth and nineteenth centuries as atmosphere and color eat away at the perspective. Landscape is the progenitor of a translucent mist that puts perspective and tone/color in opposition, because implicit in each are opposite interpretations of the wall they hang on. Pictures begin to appear that put pressure on the frame. The archetypal composition here is the edge-to-edge horizon, separating zones of sky and sea, often underlined by beach, with maybe a figure facing, as everyone does, the sea. Formal composition is gone; the frames within the frame (*coulisses, repoussoirs*, the Braille of perspective depth) have slid away. What is left is an ambiguous surface partly framed from the inside by the horizon. Such pictures (by Courbet, Caspar David Friedrich, Whistler, and hosts of little masters) are posed between infinite depth and flatness and tend to read as pattern. The powerful convention of the horizon zips easily enough through the limits of the frame.

These and certain pictures focusing on an indeterminate patch of landscape that often looks like the "wrong" subject introduce the idea of *noticing* something, of an eye scanning. This temporal quickening makes the frame an equivocal, and not an absolute, zone. Once you know that a patch of landscape represents a decision to exclude everything around it, you are faintly aware of the space outside the picture. The frame becomes a parenthesis. The separation of paintings along a wall, through a kind of magnetic repulsion, becomes inevitable. And it was accentuated and largely initiated by the new science – or art – devoted to the excision of a subject from its context: photography.

In a photograph, the location of the edge is a primary decision, since it composes – or decomposes – what it surrounds. Eventually framing, editing, cropping – establishing limits – become major acts of composition. But not so much in the beginning. There was

the usual holdover of pictorial conventions to do some of the work of framing – internal buttresses made up of convenient trees and knolls. The best early photographs reinterpret the edge without the assistance of pictorial conventions. They *lower* the tension on the edge by allowing the subject matter to compose itself, rather than consciously aligning it with the edge. Perhaps this is typical of the nineteenth century. The nineteenth century looked at a subject – not at its edges. Various fields were studied within their declared limits. Studying not the field but its limits, and defining these limits for the purpose of extending them, is a twentieth century habit. We have the illusion that we add to a field by extending it laterally, not by going, as the nineteenth century might say in proper perspective style, deeper into it. Even scholarship in both centuries has a recognizably different sense of edge and depth, of limits and definition. Photography quickly learned to move away from heavy frames and to mount a print on a sheet of board. A frame was allowed to surround the board after a neutral interval. Early photography recognized the edge but removed its rhetoric, softened its absolutism, and turned it into a zone rather than the strut it later became. One way or another, the edge as a firm convention locking in the subject had become fragile.

Much of this applied to Impressionism, in which a major theme was the edge as umpire of what's in and what's out. But this was combined with a far more important force, the beginning of the decisive thrust that eventually altered the idea of the picture, the way it was hung, and ultimately the gallery space: the myth of flatness, which became the powerful logician in painting's argument for self-definition. The development of a shallow literal space (containing invented forms, as distinct from the old illusory space containing "real" forms) put further pressures on the edge. The great inventor here is, of course, Monet.

Indeed, the magnitude of the revolution he initiated is such that there is some doubt his achievement matches it; for he is an artist of decided limitations (or one who decided on his limitations and stayed within them). Monet's landscapes often seem to have been noticed on his way to or from the real subject. There is an impres-

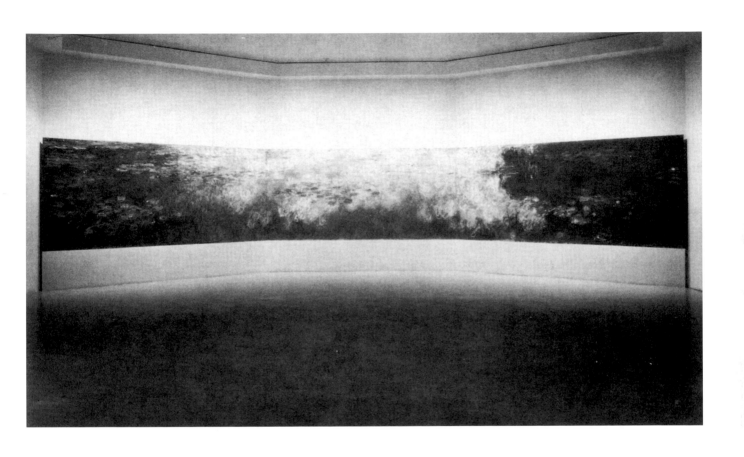

Claude Monet, *Water Lilies*, 1920, triptych: each panel 6'6" x 14',
courtesy Museum of Modern Art, New York,
Mrs. Simon Guggenheim Fund

sion that he is settling for a provisional solution; the very feature-lessness relaxes your eye to look elsewhere. The informal subject matter of Impressionism is always pointed out, but not that the subject is seen through a casual glance, one not too interested in what it's looking at. What is interesting in Monet is "looking at" this look – the integument of light, the often preposterous for-mularization of a perception through a punctate code of color and touch which remains (until near the end) impersonal. The edge eclipsing the subject seems a somewhat haphazard decision that could just as well have been made a few feet left or right. A signa-ture of Impressionism is the way the casually chosen subject sof-tens the edge's structural role at a time when the edge is under pressure from the increasing shallowness of the space. This dou-bled and somewhat opposing stress on the edge is the prelude to the definition of a painting as a self-sufficient object – a container of illusory fact now become the primary fact itself – which sets us on the high road to some stirring esthetic climaxes.

Flatness and objecthood usually find their first official text in Maurice Denis' famous statement in 1890 that before a picture is subject matter, it is first of all a surface covered with lines and col-ors. This is one of those literalisms that sounds brilliant or rather dumb, depending on the *Zeitgeist*. Right now, having seen the end-point to which nonmetaphor, nonstructure, nonillusion and non-content can take you, the *Zeitgeist* makes it sound a little obtuse. That picture plane – the ever-thinning integument of modernist integrity – sometimes seems ready for Woody Allen and has indeed attracted its share of ironists and wits. But this ignores that the powerful myth of the picture plane received its impetus from the centuries during which it sealed in unalterable systems of illusion. Conceiving it differently in the modern era was an heroic adjust-ment that signified a totally different world view, which was trivialized into esthetics, into the technology of flatness.

The literalization of the picture plane is a great subject. As the vessel of content becomes shallower and shallower, composition and subject matter and metaphysics all overflow across the edge until, as Gertrude Stein said about Picasso, the emptying out is

complete. But all the jettisoned apparatus – hierarchies of painting, illusion, locatable space, mythologies beyond number – bounded back in disguise and attached themselves, via new mythologies, to the literal surfaces, which had apparently left them no purchase. The transformation of literary myths into literal myths – object-hood, the integrity of the picture plane, the equalization of space, the self-sufficiency of the work, the purity of form – is unexplored territory. Without this change, art would have been obsolete. Indeed, its changes often seem one step ahead of obsolescence, and to that degree its progress mimics the laws of fashion.

The cultivation of the picture plane resulted in an entity with length and breadth but no thickness, a membrane which, in a metaphor usually organic, could generate its own self-sufficient laws. The primary law, of course, was that this surface, pressed between huge historical forces, could not be violated. A narrow space forced to represent without representing, to symbolize with-out benefit of received conventions, generated a plethora of new conventions without a consensus – color codes, signatures of paint, private signs, intellectually formulated ideas of structure. Cubism's concepts of structure conserved the easel painting status quo; Cubist paintings are centripetal, gathered toward the center, fading out toward the edge. (Is this why Cubist paintings tend to be small?) Seurat understood much better how to define the limits of a classic formulation at a time when edges had become equivocal. Frequently, painted borders made up of a glomeration of colored dots are deployed inward to separate out and describe the subject. The border absorbs the slow movements of the struc-ture within. To muffle the abruptness of the edge, he sometimes pattered all over the frame so that the eye could move out of the picture – and back into it – without a bump.

Matisse understood the dilemma of the picture plane and its tropism toward outward extension better than anyone. His pic-tures grew bigger as if, in a topological paradox, depth were being translated into a flat analog. On this, place was signified by up and down and left and right, by color, by drawing that rarely closed a contour without calling on the surface to contradict it, and by

paint applied with a kind of cheerful impartiality to every part of that surface. In Matisse's large paintings we are hardly ever conscious of the frame. He solved the problem of lateral extension and containment with perfect tact. He doesn't emphasize the center at the expense of the edge, or vice versa. His pictures don't make arrogant claims to stretches of bare wall. They look good almost anywhere. Their tough, informal structure is combined with a decorative prudence that makes them remarkably self-sufficient. They are easy to hang.

Hanging, indeed, is what we need to know more about. From Courbet on, conventions of hanging are an unrecovered history. The way pictures are hung makes assumptions about what is offered. Hanging editorializes on matters of interpretation and value, and is unconsciously influenced by taste and fashion. Subliminal cues indicate to the audience its deportment. It should be possible to correlate the internal history of paintings with the external history of how they were hung. We might begin our search not with a mode of display communally sanctioned (like the Salon), but with the vagaries of private insight – with those pictures of seventeenth and eighteenth century collectors elegantly sprawled in the midst of their inventory. The first modern occasion, I suppose, in which a radical artist set up his own space and hung his pictures in it was Courbet's one-man *Salon des Refusés* outside the Exposition of 1855. How were the pictures hung? How did Courbet construe their sequence, their relationship to each other, the spaces between? I suspect he did nothing startling; yet it was the first time a modern artist (who happened to be the first modern artist) had to construct the context of his work and therefore editorialize about its values.

Though pictures may have been radical, their early framing and hanging usually was not. The interpretation of what a picture implies about its context is always, we may assume, delayed. In their first exhibition in 1874, the Impressionists stuck their pictures cheek by jowl, just as they would have hung in the Salon. Impressionist pictures, which assert their flatness and their doubts about the limiting edge, are still sealed off in Beaux-Arts frames that do

little more than announce "Old Master" – and monetary – status. When William C. Seitz took off the frames for his great Monet show at the Museum of Modern Art in 1960, the undressed canvasses looked a bit like reproductions until you saw how they began to hold the wall. Though the hanging had its eccentric moments, it read the pictures' relation to the wall correctly and, in a rare act of curatorial daring, followed up the implications. Seitz also set some of the Monets flush with the wall. Continuous with the wall, the pictures took on some of the rigidity of tiny murals. The surfaces turned hard as the picture plane was "overliteralized." The difference between the easel picture and the mural was clarified.

The relation between the picture plane and the underlying wall is very pertinent to the esthetics of surface. The inch of the stretcher's width amounts to a formal abyss. The easel painting is not transferable to the wall, and one wants to know why. What is lost in the transfer? Edges, surface, the grain and bite of the canvas, the separation from the wall. Nor can we forget that the whole thing is suspended or supported – transferable, mobile currency. After centuries of illusionism, it seems reasonable to suggest that these parameters, no matter how flat the surface, are the loci of the last traces of illusionism. Mainstream painting right up to Color Field is easel painting, and its literalism is practiced against these desiderata of illusionism. Indeed, these traces make literalism interesting; they are the hidden component of the dialectical engine that gave the late modernist easel picture its energy. If you copied a late modernist easel picture onto the wall and then hung the easel picture beside it, you could estimate the degree of illusionism that turned up in the faultless literal pedigree of the easel picture. At the same time, the rigid mural would underline the importance of surface and edges to the easel picture, now beginning to hover close to an objecthood defined by the "literal" remnants of illusion – an unstable area.

The attacks on painting in the sixties failed to specify that it wasn't painting but the easel picture that was in trouble. Color Field painting was thus conservative in an interesting way, but not

to those who recognized that the easel picture couldn't rid itself of illusion and who rejected the premise of something lying quietly on the wall and behaving itself. I've always been surprised that Color Field – or late modernist painting in general – didn't try to get onto the wall, didn't attempt a rapprochement between the mural and the easel picture. But then Color Field painting conformed to the social context in a somewhat disturbing way. It remained Salon painting: it needed big walls and big collectors and couldn't avoid looking like the ultimate in capitalist art. Minimal art recognized the illusions inherent in the easel picture and didn't have any illusions about society. It didn't ally itself with wealth and power, and its abortive attempt to redefine the relation of the artist to various establishments remains largely unexplored.

Apart from Color Field, late modernist painting postulated some ingenious hypotheses on how to squeeze a little extra out of that recalcitrant picture plane, now so dumbly literal it could drive you crazy. The strategy here was simile (pretending), not metaphor (believing): saying the picture plane is "like a _____." The blank was filled in by flat things that lie obligingly on the literal surface and fuse with it, e.g., Johns' *Flags*, Cy Twombly's blackboard paintings, Alex Hay's huge painted "sheets" of lined paper, Arakawa's "notebooks." Then there is the "like a window shade," "like a wall," "like a sky" area. There's a good comedy-of-manners piece to be written about the "like a _____" solution to the picture plane. There are numerous related areas, including the perspective schema resolutely flattened into two dimensions to quote the picture plane's dilemma. And before leaving this area of rather desperate wit, one should note the solutions that cut through the picture plane (Lucio Fontana's answer to the Gordian surface) until the picture is taken away and the wall's plaster attacked directly.

Also related is the solution that lifts surface and edges off that Procrustean stretcher and pins, sticks, or drapes paper, fiberglass, or cloth directly against the wall to literalize even further. Here a lot of Los Angeles painting falls neatly – for the first time! – into the historical mainstream; it's a little odd to see this obsession with

surface, disguised as it may be with vernacular macho, dismissed as provincial impudence.

All this desperate fuss makes you realize all over again what a conservative movement Cubism was. It extended the viability of the easel picture and postponed its breakdown. Cubism was reducible to system, and systems, being easier to understand than art, dominate academic history. Systems are a kind of P.R. which, among other things, push the rather odious idea of progress. Progress can be defined as what happens when you eliminate the opposition. However, the tough opposition voice in modernism is that of Matisse, and it speaks in its unemphatic, rational way about color, which in the beginning scared Cubism gray. Clement Greenberg's *Art and Culture* reports on how the New York artists sweated out Cubism, while casting shrewd eyes on Matisse and Miró. Abstract Expressionist paintings followed the route of lateral expansion, dropped off the frame, and gradually began to conceive the edge as a structural unit through which the painting entered into a dialogue with the wall beyond it. At this point the dealer and curator enter from the wings. How they – in collaboration with the artist – presented these works, contributed, in the late forties and fifties, to the definition of the new painting.

Through the fifties and sixties, we notice the codification of a new theme as it evolves into consciousness: How much space should a work of art have (as the phrase went) to "breathe"? If paintings implicitly declare their own terms of occupancy, the somewhat aggrieved muttering between them becomes harder to ignore. What goes together, what doesn't? The esthetics of hanging evolves according to its own habits, which become conventions, which become laws. We enter the era where works of art conceive the wall as a no-man's land on which to project their concept of the territorial imperative. And we are not far from the kind of border warfare that often Balkanizes museum group shows. There is a peculiar uneasiness in watching artworks attempting to establish territory but not place in the context of the placeless modern gallery.

All this traffic across the wall made it a far-from-neutral zone.

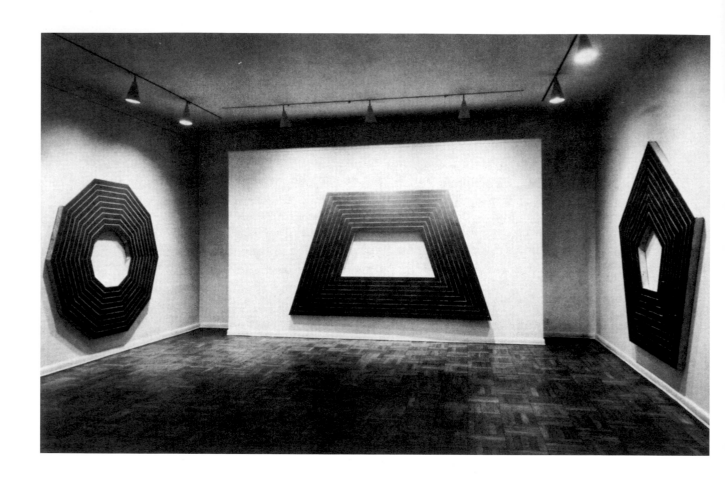

Frank Stella, installation view, 1964,
courtesy Leo Castelli Gallery, New York

28

Now a participant in, rather than a passive support for the art, the wall became the locus of contending ideologies; and every new development had to come equipped with an attitude toward it. (Gene Davis' exhibition of micro-pictures surrounded by oodles of space is a good joke about this.) Once the wall became an esthetic force, it modified anything shown on it. The wall, the context of the art, had become rich in a content it subtly donated to the art. It is now impossible to paint up an exhibition without surveying the space like a health inspector, taking into account the esthetics of the wall which will inevitably "artify" the work in a way that frequently diffuses its intentions. Most of us now "read" the hanging as we would chew gum – unconsciously and from habit. The wall's esthetic potency received a final impetus from a realization that, in retrospect, has all the authority of historical inevitability: the easel picture didn't have to be rectangular.

Stella's early shaped canvasses bent or cut the edge according to the demands of the internal logic that generated them. (Here Michael Fried's distinction between inductive and deductive structure remains one of the few practical hand tools added to the critic's black bag.) The result powerfully activated the wall; the eye frequently went searching tangentially for the wall's limits. Stella's show of striped U-,T-, and L-shaped canvasses at Castelli in 1960 "developed" every bit of the wall, floor to ceiling, corner to corner. Flatness, edge, format, and wall had an unprecedented dialogue in that small, uptown Castelli space. As they were presented, the works hovered between an ensemble effect and independence. The hanging there was as revolutionary as the paintings; since the hanging was part of the esthetic, it evolved simultaneously with the pictures. The breaking of the rectangle formally confirmed the wall's autonomy, altering for good the concept of the gallery space. Some of the mystique of the shallow picture plane (one of the three major forces that altered the gallery space) had been transferred to the context of art.

This result brings us back again to that archetypal installation shot – the suave extensions of the space, the pristine clarity, the pictures laid out in a row like expensive bungalows. Color Field

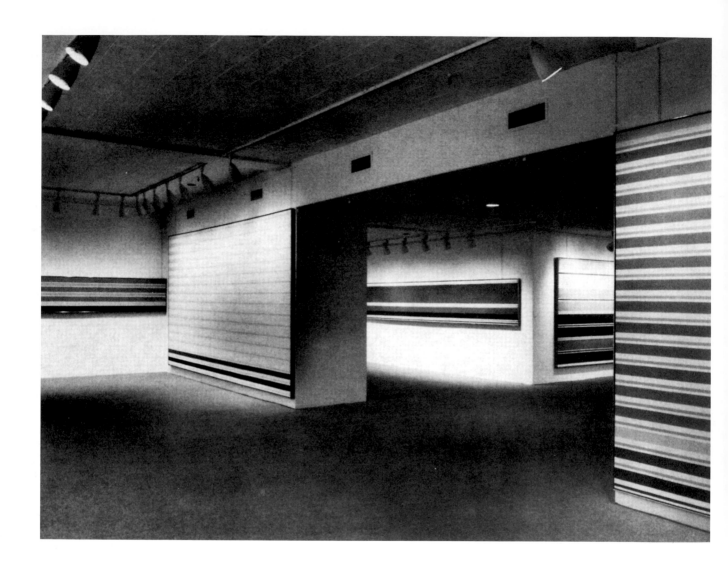

Kenneth Noland, installation view, 1967,
courtesy André Emmerich Gallery, New York

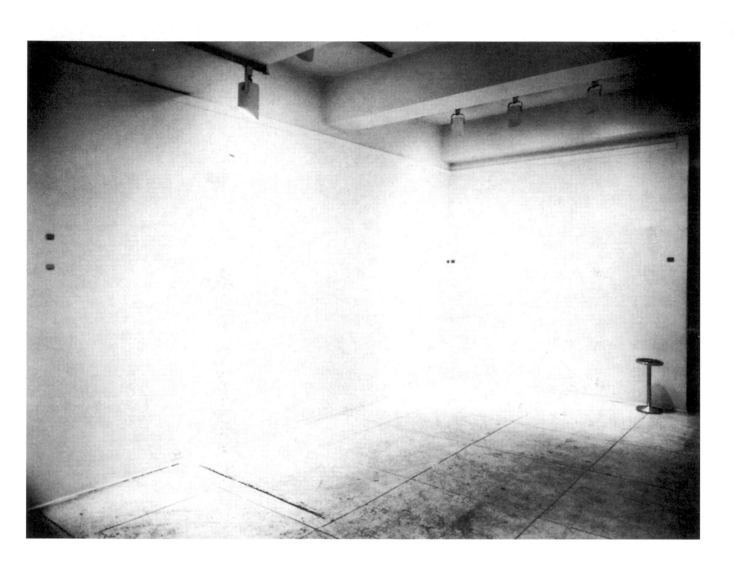

Gene Davis, installation view, 1968, courtesy Fischbach Gallery,
New York (photo: John A. Ferrari)

31

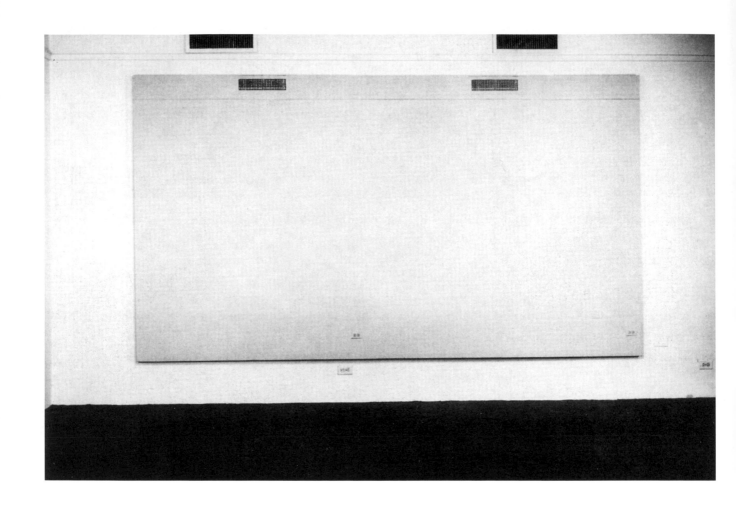

William Anastasi, *West Wall, Dwan Main Gallery,* 1967
(photo: Walter Russell)

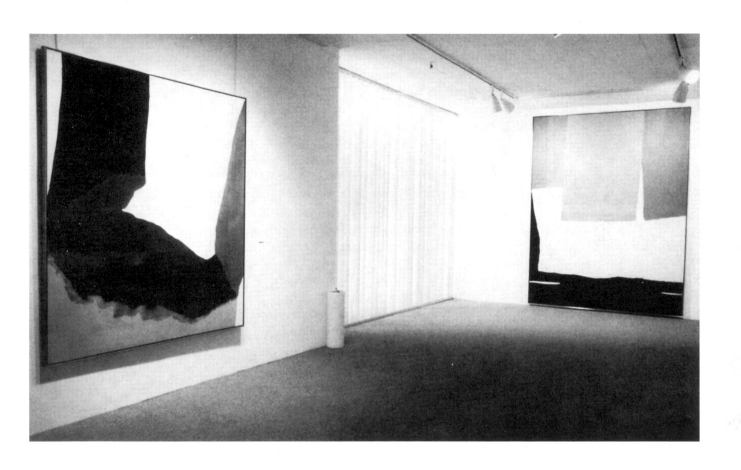

Helen Frankenthaler, installation view, 1968,
courtesy André Emmerich Gallery

painting, which inevitably comes to mind here, is the most imperial of modes in its demand for *lebensraum*. The pictures recur as reassuringly as the columns in a classic temple. Each demands enough space so that its effect is over before its neighbor's picks up. Otherwise, the pictures would be a single perceptual field, frank ensemble painting, detracting from the uniqueness claimed by each canvas. The Color Field installation shot should be recognized as one of the teleological endpoints of the modern tradition. There is something splendidly luxurious about the way the pictures and the gallery reside in a context that is fully sanctioned socially. We are aware we are witnessing a triumph of high seriousness and hand-tooled production, like a Rolls Royce in a showroom that began as a Cubist jalopy in an outhouse.

What comment can you make on this? A comment has been made already, in an exhibition by William Anastasi at Dwan in New York in 1965. He photographed the empty gallery at Dwan, noticed the parameters of the wall, top and bottom, right and left, the placement of each electrical outlet, the ocean of space in the middle. He then silkscreened all this data on a canvas slightly smaller than the wall and put it on the wall. Covering the wall with an image of that wall delivers a work of art right into the zone where surface, mural, and wall have engaged in dialogues central to modernism. In fact, this history was the theme of these paintings, a theme stated with a wit and cogency usually absent from our written clarifications. For me, at least, the show had a peculiar after-effect; when the paintings came down, the wall became a kind of ready-made mural and so changed every show in that space thereafter.

II. The Eye and the Spectator

Couldn't modernism be taught to children as a series of Aesop's fables? It would be more memorable than art appreciation. Think of such fables as "Who Killed Illusion" or "How the Edge Revolted Against the Center." "The Man Who Violated the Canvas" could follow "Where Did the Frame Go?" It would be easy to draw morals: think of "The Vanishing Impasto That Soaked Away – and Then Came Back and Got Fat." And how would we tell the story of the little Picture Plane that grew up and got so mean? How it evicted everybody, including Father Perspective and Mother Space, who had raised such nice real children, and left behind only this horrid result of an incestuous affair called Abstraction, who looked down on everybody, including – eventually – its buddies, Metaphor and Ambiguity; and how Abstraction and the Picture Plane, thick as thieves, kept booting out a persistent guttersnipe named Collage, who just wouldn't give up. Fables give you more latitude than art history. I suspect art historians have fantasies about their fields they would like to make stick. This is a preface to some generalizations about Cubism and collage that seem equally true and fictitious, and thus compose a fairy tale for adults.

The forces that crushed four hundred years of illusionism and idealism together and evicted them from the picture translated deep space into surface tension. This surface responds as a field to any mark on it. One mark was enough to establish a relationship not so much with the next as with the esthetic and ideological potency of the blank canvas. The content of the empty canvas increased as modernism went on. Imagine a museum of such potencies, a temporal corridor hung with blank canvasses – from 1850, 1880, 1910, 1950, 1970. Each contains, before a brush is laid on it, assumptions implicit in the art of its era. As the series approaches the present, each member accumulates a more com-

plex latent content. Modernism's classic void ends up stuffed with ideas all ready to jump on the first brushstroke. The specialized surface of the modern canvas is as aristocratic an invention as human ingenuity ever evolved.

Inevitably, what went *on* that surface, paint itself, became the locus of conflicting ideologies. Caught between its substance and its metaphorical potential, paint re-enacted in its material body the residual dilemmas of illusionism. As paint became subject, object, and process, illusionism was squeezed out of it. The integrity of the picture plane and the morality of the medium favor lateral extension. The mainstream as scheduled from Cézanne to Color Field glides along the wall, measures it with vertical and horizontal coordinates, maintains the propriety of gravity and the upright viewer. This is the etiquette of normal social discourse, and through it the mainstream viewer is continually reintroduced to the wall, which in turn supports the canvas – its surface now so sensitive that an object on it would cause it, as it were, to blink.

But as high art vacuumed the picture plane, the vernacular surpassed itself in transgressing its common habitat. While the Impressionists occluded traditional perspective with a curtain of paint, popular painters and photographers in many countries gamed with illusion from Archimboldesque grotesqueries to trompe l'oeil. Shells, glitter, hair, stones, minerals, and ribbons were attached to postcards, photographs, frames, shadowboxes. This tacky efflorescence, saturated in the Victorian's corrupt version of short-term memory – nostalgia – was, of course, a substratum of Symbolism and Surrealism. So when, in 1911, Picasso stuck that piece of oil cloth printed with chair-caning on a canvas, some advanced colleagues may have seen it as a *retardataire* gesture.

That work is now collage's Exhibit A. Artists, historians, critics are always tramping back to 1911 to take a look at it. It marks an irrevocable through-the-looking-glass passage from the picture's space into the secular world, the spectator's space. Analytic Cubism didn't push laterally but poked out the picture plane, contradicting previous advances in defining it. Facets of space are thrust forward;

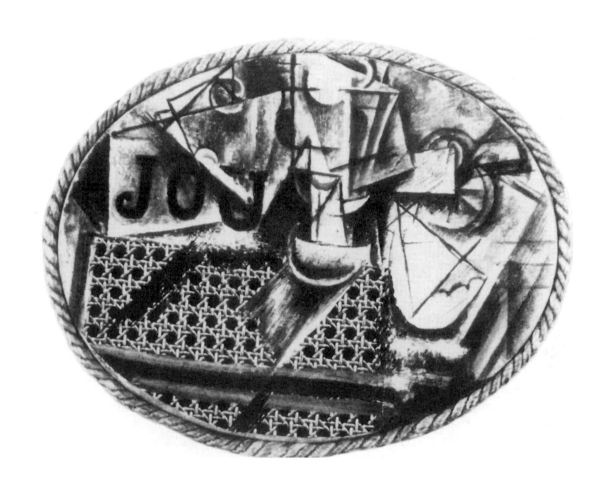

Pablo Picasso, *Still Life with Chair Caning*, 1911

37

sometimes they look stuck on the surface. Bits of Analytic Cubism, then, could already be seen as a kind of *collage manqué*.

The moment a collage was attached to that unruly cubist surface there was an instantaneous switch. No longer able to pin a subject together in a space too shallow for it, the multiple vanishing points of the Analytic Cubist picture shower out into the room with the spectator. His point of view ricochets among them. The surface of the picture is made opaque by collage. Behind it is simply a wall, or a void. In front is an open space in which the viewer's sense of his own presence becomes an increasingly palpable shadow. Expelled from the Eden of illusionism, kept out by the literal surface of the picture, the spectator becomes enmeshed in the troubled vectors that provisionally define the modernist sensibility. The impure space in which he stands is radically changed. The esthetics of discontinuity manifest themselves in this altered space and time. The autonomy of parts, the revolt of objects, pockets of void become generative forces in all the arts. Abstraction and reality – not realism – conduct this rancorous argument throughout modernism. The picture plane, like an exclusive country club, keeps reality out and for good reason. Snobbishness is, after all, a form of purity, prejudice a way of being consistent. Reality does not conform to the rules of etiquette, subscribe to exclusive values, or wear a tie; it has a vulgar set of relations and is frequently seen slumming among the senses with other antithetical arts.

Both abstraction and reality, however, are implicated in that sacred twentieth century dimension, space. The exclusive division between them has blurred the fact that the first has considerable practical relevance – contrary to the modern myth that art is "useless." If art has any cultural reference (apart from being "culture") surely it is in the definition of our space and time. The flow of energy between concepts of space articulated through the artwork and the space we occupy is one of the basic and least understood forces in modernism. Modernist space redefines the observer's status, tinkers with his self-image. Modernism's conception of space, not its subject matter, may be what the public rightly conceives as threatening. Now, of course, space contains no threats,

has no hierarchies. Its mythologies are drained, its rhetoric collapsed. It is simply a kind of undifferentiated potency. This is not a "degeneration" of space but the sophisticated convention of an advanced culture which has cancelled its values in the name of an abstraction called "freedom." Space now is not just where things happen; things make space happen.

Space was clarified not only in the picture, but in the place where the picture hangs – the gallery, which, with postmodernism, joins the picture plane as a unit of discourse. If the picture plane defined the wall, collage begins to define the entire space. The fragment from the real world plonked on the picture's surface is the imprimatur of an unstoppable generative energy. Do we not, through an odd reversal, as we stand in the gallery space, end up *inside* the picture, looking out at an opaque picture plane that protects us from a void? (Could Lichtenstein's paintings in the *back* of a canvas be a text for this?) As we move around that space, looking at the walls, avoiding things on the floor, we become aware that that gallery also contains a wandering phantom frequently mentioned in avant-garde dispatches – the Spectator.

Who is this Spectator, also called the Viewer, sometimes called the Observer, occasionally the Perceiver? It has no face, is mostly a back. It stoops and peers, is slightly clumsy. Its attitude is inquiring, its puzzlement discreet. He – I'm sure it is more male than female – arrived with modernism, with the disappearance of perspective. He seems born out of the picture and, like some perceptual Adam, is drawn back repeatedly to contemplate it. The Spectator seems a little dumb; he is not you or me. Always on call, he staggers into place before every new work that requires his presence. This obliging stand-in is ready to enact our fanciest speculations. He tests them patiently and does not resent that we provide him with directions and responses: "The viewer feels…"; "the observer notices…"; "the spectator moves…." He is sensitive to effects: "The effect on the spectator is…." He smells out ambiguities like a bloodhound: "caught between these ambiguities, the spectator…." He not only stands and sits on command; he lies down and even crawls as modernism presses on him its final indignities.

Roy Lichtenstein, Stretcher Frame, 1968,
courtesy Irving Blum (photo: Rudolph Burckhardt)

Plunged into darkness, deprived of perceptual cues, blasted by strobes, he frequently watches his own image chopped up and recycled by a variety of media. Art conjugates him, but he is a sluggish verb, eager to carry the weight of meaning but not always up to it. He balances; he tests; he is mystified, demystified. In time, the Spectator stumbles around between confusing roles: he is a cluster of motor reflexes, a dark-adapted wanderer, the vivant in a tableau, an actor manqué, even a trigger of sound and light in a space land-mined for art. He may even be told that he himself is an artist and be persuaded that his contribution to what he observes or trips over is its authenticating signature.

Yet the Spectator has a dignified pedigree. His genealogy includes the eighteenth century rationalist with an astute eye – Addison's Spectator, perhaps, whose gallery equivalent is called "the onlooker" and "the beholder." A closer antecedent is the Romantic self, which quickly splits to produce an actor and an audience, a protagonist and an eye that observes him.

This Romantic split is comparable to the addition of the third actor to the Greek stage. Levels of awareness are multiplied, relationships reformed, new voids filled in with meta-commentary by the audience. The Spectator and his snobbish cousin the Eye arrive in good company. Delacroix calls them up occasionally; Baudelaire hobnobs with them. They are not on such good terms with each other. The epicene Eye is far more intelligent than the Spectator, who has a touch of male obtuseness. The Eye can be trained in a way the Spectator cannot. It is a finely tuned, even noble organ, esthetically and socially superior to the Spectator. It is easy for a writer to have a Spectator around – there is something of the Eternal Footman about him. It is more difficult to have an Eye, although no writer should be without one. Not having an Eye is a stigma to be hidden, perhaps by knowing someone who has one.

The Eye can be directed but with less confidence than the Spectator, who, unlike the Eye, is rather eager to please. The Eye is an oversensitive acquaintance with whom one must stay on good terms. It is often quizzed a little nervously, its responses received

41

respectfully. It must be waited on while it observes – observation being its perfectly specialized function: "The eye discriminates between The eye resolves The eye takes in, balances, weighs, discerns, perceives" But like any thoroughbred, it has its limits. "Sometimes the eye fails to perceive" Not always predictable, it has been known to lie. It has trouble with content, which is the last thing the Eye wants to see. It is no good at all for looking at cabs, bathroom fixtures, girls, sports results. Indeed, it is so specialized it can end up watching itself. But it is unmatched for looking at a particular kind of art.

The Eye is the only inhabitant of the sanitized installation shot. The Spectator is not present. Installation shots are generally of *abstract* works; realists don't go in for them much. In installation shots the question of scale is confirmed (the size of the gallery is deduced from the photo) and blurred (the absence of a Spectator could mean the gallery is 30 feet high). This scalelessness conforms with the fluctuations through which reproduction passes the successful work of art. The art the Eye is brought to bear on almost exclusively is that which preserves the picture plane – mainstream modernism. The Eye maintains the seamless gallery space, its walls swept by flat planes of duck. Everything else – all things impure, including collage – favors the Spectator. The Spectator stands in space broken up by the consequences of collage, the second great force that altered the gallery space. When the Spectator is Kurt Schwitters, we are brought to a space we can only occupy through eyewitness reports, by walking our eyes through photographs that tantalize rather than confirm experience: his *Merzbau* of 1923 at Hanover, destroyed in 1943.

"It grows about the way a big city does," wrote Schwitters, "when a new building goes up, the Housing Bureau checks to see that the whole appearance of the city is not going to be ruined. In my case, I run across something or other that looks to me as though it would be right for the KdeE [Cathedral of Erotic Misery], so I pick it up, take it home, and attach it and paint it, always keeping in mind the rhythm of the whole. Then a day comes when I realize I have a corpse on my hands – relics of a movement in art

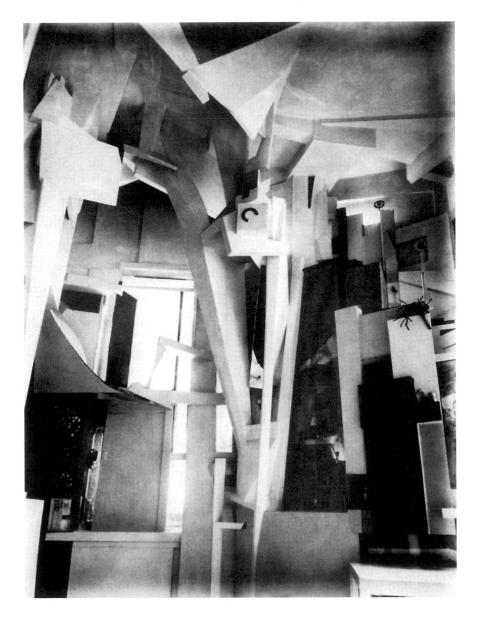

Kurt Schwitters, *Merzbau*, begun 1923 – destroyed 1943,
Hanover, Germany

43

that is now passé. So what happens is that I leave them alone, only I cover them up either wholly or partly with other things, making clear that they are being downgraded. As the structure grows bigger and bigger, valleys, hollows, caves appear, and these lead a life of their own within the overall structure. The juxtaposed surfaces give rise to forms twisting in every direction, spiraling upward. An arrangement of the most strictly geometrical cubes covers the whole, underneath which shapes are curiously bent or otherwise twisted until their complete dissolution is achieved."

Witnesses don't report on themselves *in* the *Merzbau*. They look *at* it, rather than experience themselves in it. The Environment was a genre nearly forty years away, and the idea of a surrounded spectator was not yet a conscious one. All recognized the invasion of space, the author being, as Werner Schmalenbach put it, "progressively dispossessed." The energy powering this invasion is not recognized, though mentioned by Schwitters, for if the work had any organizing principle, it was the mythos of a city. The city provided materials, models of process, and a primitive esthetic of juxtaposition – congruity forced by mixed needs and intentions. The city is the indispensable context of collage and of the gallery space. Modern art needs the sound of traffic outside to authenticate it.

The *Merzbau* was a tougher, more sinister work than it appears in the photographs available to us. It grew out of a studio – that is, a space, materials, an artist, and a process. Space extended (upstairs and downstairs) and so did time (to about 13 years). The work cannot be remembered as static, as it looks in photographs. Framed by meters and years, it was a mutating, polyphonic construct, with multiple subjects, functions, concepts of space and of art. It contained in reliquaries mementos of such friends as Gabo, Arp, Mondrian, and Richter. It was an autobiography of voyages in the city. There was a "morgue" of city scenarios (*The Sex Crime Cave, The Cathedral of Erotic Misery, The Grotto of Love, The Cave of the Murderers*). Cultural tradition was preserved (*The Niebelungen Cave, The Goethe Cave,* the absurd *Michelangelo Exhibition*). It revised history (*The Cave of Depreciated Heroes*) and offered models of behavior (*The Caves of Hero Worship*) – two built-in systems of

value that, like their environment, were subject to change. Most of these Expressionist/Dada conceits were buried, like guilt, by the later Constructivist overlay that turned the *Merzbau* into a utopian hybrid: part practical design (desk, stool), part sculpture, part architecture. As the Expressionism/Dada was collaged over, esthetic history was literalized into an archeological record. The Constructivism did not clarify the structure, which remained, as Schmalenbach says, "irrational space." Both space and artist – we tend to think of them together – exchanged identities and masks. As the author's identities are externalized onto his shell/cave/room, the walls advance upon him. Eventually he flits around a shrinking space like a piece of moving collage.

There is something involutional and inside-out about the *Merzbau*. Its concepts had a kind of nuttiness that some visitors acknowledged by commenting on its *lack* of eccentricity. Its numerous dialectics – between Dada and Constructivism, structure and experience, the organic and the archeological, the city outside, the space inside – spiral around one work: *transformation*. Kate Steinitz, the *Merzbau*'s most perceptive visitor, noticed a cave "in which a bottle of urine was solemnly displayed so that the rays of light that fell on it turned the liquid to gold." The sacramental nature of transformation is deeply connected to Romantic idealism; in its expressionist phase it tests itself by performing rescue operations among the most degraded materials and subjects. Initially the picture plane is an idealized transforming space. The transformation of objects is contextual, a matter of relocation. Proximity to the picture plane assists this transformation. When isolated, the context of objects is the gallery. Eventually, the gallery itself becomes, like the picture plane, a transforming force. At this point, as Minimalism demonstrated, art can be literalized and detransformed; the gallery will make it art anyway. Idealism is hard to extinguish in art, because the empty gallery itself becomes *art manqué* and so preserves it. Schwitter's *Merzbau* may be the first example of a "gallery" as a chamber of transformation, from which the world can be colonized by the converted eye.

Schwitter's career offers another example of an intimate space

defined by his proprietary aura. During his stay in a British deten-tion camp for enemy aliens, on the Isle of Wight, he established a living space under a table. This creation of place in a camp for dis-placed people is animal, ludicrous, and dignified. In retrospect, this space, which, like the *Merzbau*, we can only remember, sig-nifies how firmly Schwitters forced a reciprocal function between art and life, mediated in this case by just living. Like pieces of Merz, the trivia of sub-tabular occupancy, curtained by moving feet, are transformed in time, by day-to-day living, into ritual. Could we now say this was partly a performance piece in a self-created proto-gallery?

Schwitters' *Merzbau*, like other Cubist collages, sports an odd letter – letters and words being donors of, in Braque's view, "a feel-ing of certainty." Collage is a noisy business. A soundtrack accom-panies its words and letters. Without going into the attractive com-plexities of the letter and the word in modernism, they are disrup-tive. From Futurism to the Bauhaus, words cut across media and literally force themselves on stage. All mixed movements have a theatrical component which runs parallel to the gallery space but which, in my view, doesn't contribute much to its definition. Theat-rical conventions die in the gallery. Schwitters may have recog-nized this when he separated his two kinds of theater: one was a chaotic multi-sensory actualization of the *Merzbau*, enveloping the spectator; the other a clarification of the conventional stage through Constructivism. Neither really intrudes on the gallery space, though the immaculate gallery does show some traces of Constructivist housekeeping. Performance in the gallery sub-scribes to an entirely different set of conventions from stage performance.

Schwitters' recitations broke the conventions of ordinary life – talking, lecturing. The way his properly dressed person framed his utterances must have been disorienting – like a bank teller passing you a hold-up note after cashing your check. In a letter to Raoul Hausmann he reports on a visit to Van Doesburg's group in 1923-24:

"Doesburg read a very good dadaistic Program [in the Hague], in which

he said the dadaist would do something unexpected. At that moment I
rose from the middle of the Publick and barked loud. Some people fainted
and were carried out, and the Papers reported, that Dada means barking.
At once we got Engagements from Haarlem and Amsterdam. It was sold
out in Haarlem, and I walked so that all could see me, and all waited that
I should bark. Doesburg said again, I would do something unexpected.
This time I blew my nose. The papers wrote phat [sic] I didnot bark, that I
blew only my nose. In Amsterdam it was so full, that people gave phan-
tastic prises [sic] to get still a seat, I didnt bark, nor blow my nose. I recited
the Revolution. A lady could not stop laughing and had to be carried
out."

The gestures are precise and could be briefly interpreted – "I am
a dog, a sneezer, a pamphlet." Like pieces of Merz, they are col-
laged into a set situation (environment), from which they derive
energy. The indeterminacy of that context is favorable ground for
the growth of new conventions, which in the theater would be
smothered by the convention of "acting."

Happenings were first enacted in indeterminate, nontheatrical
spaces – warehouses, deserted factories, old stores. Happenings
mediated a careful stand-off between avant-garde theater and
collage. They conceived the spectator as a kind of collage in that
he was spread out over the interior – his attention split by simul-
taneous events, his senses disorganized and redistributed by firmly
transgressed logic. Not much was said at most Happenings, but,
like the city that provided their themes, they literally crawled with
words. *Words*, indeed, was the title of an Environment with which
Allan Kaprow enclosed the spectator in 1961: *Words* contained
circulating names (people) who were invited to contribute words
on paper to attach to walls and partitions. Collage seems to have a
latent desire to turn itself outside-in; there is something womblike
about it.

Yet the realization of the Environment was oddly retarded. Why
is there almost nothing Environmental between Cubism and
Schwitters – barring forthcoming Russian surprises – or between
Schwitters and the Environments of the late fifties and early sixties
which arrive in a cluster with Fluxus, the New Realists, Kaprow,
Kienholz, and others? It may be that illustrative Surrealism, con-

Allan Kaprow, *An Apple Shrine*, Environment, 1960,
courtesy Judson Gallery, New York (photo: Robert McElroy)

serving the illusion within the picture, avoided the implications of the expulsion from the picture plane into real space. Within this time there are great landmarks and gestures that conceive of the gallery as a unit – Lissitzky designed a modern gallery space in 1925 in Hanover, as Schwitters was working at his *Merzbau*. But with some doubtful exceptions (Duchamp's coal bags and string?), they do not emerge from collage. Environmental collage and assemblage clarify themselves with the acceptance of the tableau as a genre. With tableaux (Segal, Kienholz), the illusionistic space within the traditional picture is actualized in the box of the gallery. The passion to actualize even illusion is a mark – even a stigma – of sixties art. With the tableau, the gallery "impersonates" other spaces. It is a bar (Kienholz), a hospital room (Kienholz), a gas station (Segal), a bedroom (Oldenburg), a living room (Segal), a "real" studio (Samaras). The gallery space "quotes" the tableaux and makes them art, much as their representation became art within the illusory space of a traditional picture.

The spectator in a tableau somehow feels he shouldn't be there. Segal's art makes this clearer than anyone else's. His objects – great lumps of them – wear a history of previous occupancy, whether bus or diner or door. Their familiarity is distanced by the gallery context and by the sense of occupancy conveyed by the plaster figures. The figures freeze this history of usage at a particular time. Like period rooms, Segal's pieces are closely time-bound while they imitate timelessness. Since the environment is occupied already, our relationship to it is partly preempted by the figures, which have the blush of life completely withdrawn from them. They – even in their mode of manufacture – are simulacra of the living and ignore us with some of the irritating indifference of the dead. Despite their postures, which signify rather than enact relationships, they also seem indifferent to each other. There is a slow, abstract lapse between each of them and between them and their environment. Their occupancy of their environment is a large subject. But the effect on the spectator who joins them is one of trespass. Because trespass makes one partly visible to oneself, it plays down body language, encourages a convention of silence,

and tends to substitute the Eye for the Spectator. This is exactly what would happen if Segal's tableaux were painted pictures. It is a very sophisticated form of "realism." Segal's white plaster is a convention of removal, which also removes us from ourselves.

Encountering a Hanson or a de Andrea is shocking; it violates our own sense of reality or the reality of our senses. They trespass not only on our space but on our credibility. They derive, in my view, not so much from sculpture as from collage, something taken indoors and artified by the gallery. Outdoors, in the proper context, they would be accepted as live, that is, would not be looked at twice. They are stations on the way to the ultimate piece of collage – the living figure. This figure was provided at O.K. Harris in 1972 by Carlin Jeffrey: the living sculpture, which, like a piece of collage, declared – on request – its own history. A live figure as a collage returns us to Picasso's costumes for *Parade*, a walking Cubist picture; and it is a good point at which to pick up these two modern familiars, the Eye and the Spectator, again.

The Eye and the Spectator set off in different directions from Analytic Cubism. The Eye goes along with Synthetic Cubism as it takes up the business of redefining the picture plane. The Spectator, as we have seen, copes with the invasion of real space from Pandora's picture plane, opened by collage. These two directions – or traditions, as the critic Gene Swenson called them – vie with each other in their opprobrium. The Eye looks down on the Spectator; the Spectator thinks the Eye is out of touch with real life. The comedies of the relationship are of Wildean proportions; an Eye without a body and a body without much of an Eye usually cut each other dead. Yet they indirectly maintain a kind of dialogue no one wants to notice. And in late modernism the two come together for the purpose of refreshing their misunderstanding. After modernism's final – and American – climax, the Eye bears Pollack's picture plane off triumphantly toward Color Field; the Spectator brings it into real space where anything can happen.

In the late sixties and seventies, Eye and Spectator negotiate some transactions. Minimal objects often provoked perceptions other than the visual. Though what was there instantly declared

Claes Oldenburg, Happening from "The Street,"
courtesy Leo Castelli Gallery, New York (photo: Martha Holmes)

itself to the eye, it had to be checked; otherwise, what was the point of three-dimensionality? There are two kinds of time here: the eye apprehended the object at once, like painting, then the body bore the eye around it. This prompted a feedback between expectation confirmed (checking) and hitherto subliminal bodily sensation. Eye and Spectator were not fused but cooperated for the occasion. The finely tuned Eye was impressed with some residual data from its abandoned body (the kinesthetics of gravity, tracking, etc.). The Spectator's other senses, always there in the raw, were infused with some of the Eye's fine discriminations. The Eye urges the body around to provide it with information – the body becomes a data-gatherer. There is heavy traffic in both directions on this sensory highway – between sensation conceptualized and concept actualized. In this unstable rapprochement lie the origins of perceptual scenarios, performance, and Body Art.

The empty gallery, then, is not empty. Its walls are sensitized by the picture plane, its space primed by collage; and it contains two tenants with a long-term lease. Why was it necessary to invent them? Why do the Eye and the Spectator separate themselves out from our daily persons to interrupt and double our senses?

It often feels as if we can no longer experience anything if we don't first alienate it. In fact, alienation may now be a necessary preface to experience. Anything too close to us bears the label "Objectify and Re-ingest." This mode of handling experience – especially art experience – is inescapably modern. But while its pathos is obvious, it is not all negative. As a mode of experience it can be called degenerate, but it is no more so than our "space" is degenerate. It is simply the result of certain necessities pressed upon us. Much of our experience can only be brought home through mediation. The vernacular example is the snapshot. You can only see what a good time you had from the summer snapshots. Experience can then be adjusted to certain norms of "having a good time." These Kodachrome icons are used to convince friends you did have a good time – if they believe it, you believe it. Everyone wants to have photographs not only to prove but to invent their experience. This constellation of narcissism, insecurity, and pathos is so

Lucas Samaras, *Bedroom*, 1964,
courtesy The Pace Gallery, New York

Allan Kaprow, *Words* (detail), Environment, 1962

influential I suppose none of us is quite free of it.

So in most areas of experience there is a busy traffic in proxies and surrogates. The implication is that direct experience might kill us. Sex used to be the last stand where privacy preserved direct experience without the interposition of models. But when sex went public, when its study became as unavoidable as tennis, the fatal surrogate entered, promising "real" experience by the very consciousness of self that makes it inaccessible. Here, as with other mediated experience, "feeling" is turned into a consumer product. Modern art, however, in this as in other areas, was ahead of its time. For the Viewer – literally something you look through – and the Eye validate experience. They join us whenever we enter a gallery, and the solitariness of our perambulations is obligatory, because we are really holding a mini-seminar with our surrogates. To that exact degree, we are absent. Presence before a work of art, then, means that we absent ourselves in favor of the Eye and Spectator, who report to us what we might have seen had we been there. The absent work of art is frequently more present to us. (I believe Rothko understood this better than any other artist.) This complex anatomy of looking at art is our "elsewhere" trip; it is fundamental to our provisional modern identity, which is always being reconditioned by our labile senses. For the Spectator and the Eye are conventions which stabilize our missing sense of ourselves. They acknowledge that our identity is itself a fiction, and they give us the illusion we are present through a double-edged self-consciousness. We objectify and consume art, then, to nourish our nonexistent selves or to maintain some esthetic starveling called "formalist man." All this is clearer if we go back to that moment when a picture became an active partner in perception.

Impressionism's first spectators must have had a lot of trouble seeing the pictures. When an attempt was made to verify the subject by going up close, it disappeared. The Spectator was forced to run back and forth to trap bits of content before they evaporated. The picture, no longer a passive object, was issuing instructions. And the Spectator began to utter his first complaints: not only "What is it supposed to be?" and "What does it mean?" but

Claes Oldenburg, *Bedroom Ensemble*, 1963,
courtesy National Gallery of Canada, Ottawa

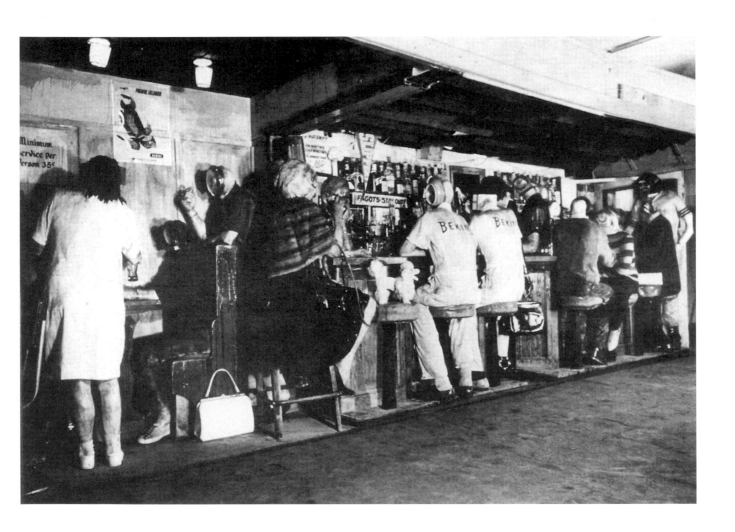

Edward Kienholz, *The Beanery* (detail), 1965,
collection of the Stedelijk Museum, Amsterdam

57

Duane Hanson, *Man with Hand Truck*, 1975,
courtesy O.K. Harris Works of Art, New York (photo: Eric Pollitzer)

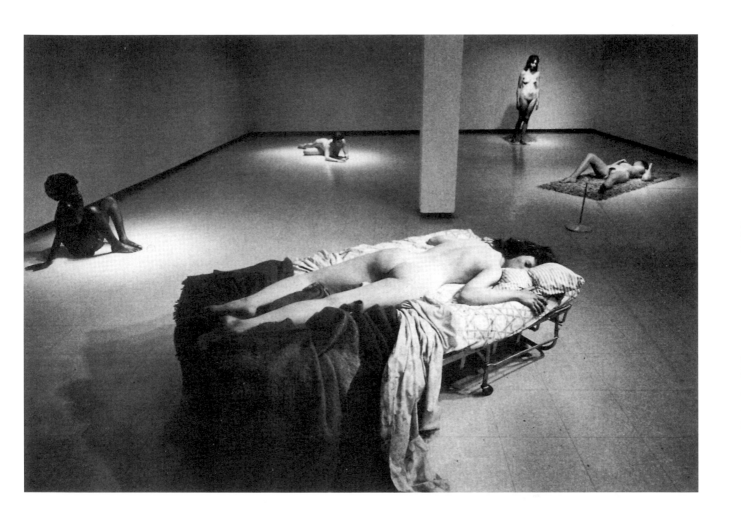

John de Andrea, installation view, 1974,
courtesy O.K. Harris Works of Art, New York

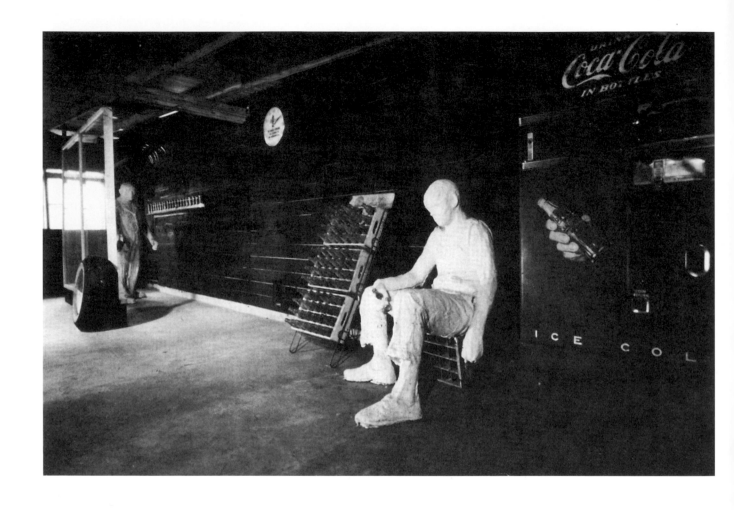

George Segal, *Gas Station*, 1968,
courtesy National Gallery of Canada, Ottawa

60

"Where am I supposed to stand?" Problems of deportment are intrinsic to modernism. Impressionism began that harassment of the Spectator inseparable from most advanced art. As we read avant-garde dispatches, it seems that modernism paraded through a vast sensory anguish. For once the object of scrutiny becomes active; our senses are on trial. Modernism underlines the fact that "identity" in the twentieth century is centered around perception, on which subject philosophy, physiology, and psychology have also converged major efforts. Indeed, just as *systems* were a nineteenth century obsession, *perception* is a twentieth. It mediates between object and idea and includes both. Once the "active" artwork is included in the perceptual arc, the senses are called into question; and since the senses apprehend the data that confirm identity, identity becomes problematic.

The Eye then stands for two opposite forces: the fragmentation of the self and the illusion of holding it together. The Spectator makes possible such experience as we are allowed to have. Alienation and esthetic distance become confused – and not unprofitably. It seems like an unstable situation: a fractured self, senses on the blink, surrogates employed in tasks of fine discrimination. But it's a tight little system with a lot of stability built into it. It is reinforced every time you call on the Eye and the Spectator.

But the Eye and the Spectator stand for more than slipping senses and mutating identity. When we became self-conscious about looking at a work of art (looking at ourselves looking), any certainty about what's "out there" was eroded by the uncertainties of the perceptual process. The Eye and the Spectator stand for that process, which continually restates the paradoxes of consciousness. There is an opportunity to dispense with those two surrogates and experience "directly." Such experience, of course, cancels the self-consciousness that sustains memory. So Eye and Spectator acknowledge the desire for direct experience, at the same time they recognize that the modernist consciousness can only temporarily submerge itself in process. Again the Eye and Spectator emerge with a double function – as much curators of our consciousness as subverters of it. Some postmodern art shows an

Carlin Jeffrey, installation view, 1972,
courtesy O.K. Harris Works of Art, New York
(photo: Eric Pollitzer)

Joseph Kosuth, installation view, 1972,
courtesy Leo Castelli Gallery, New York

exact appreciation of this. Its quotas of process are frozen by those traces of organized memory – documentation, which provides not the experience, but the evidence of it.

Process, then, gives us opportunities to eliminate the Eye and the Spectator as well as to institutionalize them; and this has happened. Hard-core Conceptualism eliminates the Eye in favor of the mind. The audience reads. Language is reasonably well equipped to examine the sets of conditions that formulate art's end-product: "meaning." This inquiry tends to become self-referential or contextual – that is, more like art or more like the conditions that sustain it.

One of these conditions is the gallery space. Thus there is a marvelous paradox about Joseph Kosuth's "installation" at Castelli in 1972: the tables, the benches, the open books. It is not a looking room, it is a reading room. The ceremony of informality is deceptive. Here is the aura of Wittgenstein's study, as we might imagine it. Or is it a schoolroom? Bare, essential, even puritanical, it cancels as well as draws on the special cloister of esthetics that the gallery is. It is a remarkable image.

So is its opposite – an image of a man in a gallery threatening his own substance with implicit or explicit violence. If Conceptualism eliminates the Eye by once again making it the servant of the mind, Body Art, such as Chris Burden's, identifies the Spectator with the artist and the artist with art – a sacramental trinity. The punishment of the Spectator is a theme of advanced art. Eliminating the Spectator by identifying him with the artist's body and enacting on that body the vicissitudes of art and process is an extraordinary conceit. We perceive again the double movement. Experience is made possible but only at the price of alienating it. There is something infinitely pathetic about the single figure in the gallery, testing limits, ritualizing its assaults on its body, gathering scanty information on the flesh it cannot shake off.

In these extreme cases art becomes the life of the mind or the life of the body, and each offers its returns. The Eye disappears into the mind, and the Spectator, in a surrogate's phantom suicide, induces his own elimination.

III. Context as Content

When we all had front doors – not intercom and buzzer – the knock at the door still had some atavistic resonance. De Quincy got off one of his best passages on the knocking at the gate in *Macbeth*. The knocking announces that "the awful parenthesis" – the crime – is over and that "the goings-on of the world in which we live" are back. Literature places us as knocker (Mrs. Blake answering the door since Mr. Blake is in Heaven and must not be disturbed) and knockee (the visitor from Porlock bringing Coleridge down from his *Kubla Khan* high). The unexpected visitor summons anticipation, insecurity, even dread – despite that it's usually nothing, sometimes a kid who knocked and ran away.

If the house is the house of modernism, what knocks can you expect? The house itself, built on ideal foundations, is imposing, even though the neighborhood is changing. It has a Dada kitchen, a fine Surrealist attic, a utopian playroom, a critics' mess, clean, well-lighted galleries for what is current, votive lights to various saints, a suicide closet, vast storage rooms, and a basement flophouse where failed histories lie around mumbling like bums. We hear the Expressionist's thunderous knock, the Surrealist's coded knock, the Realist at the tradesman's entrance, the Dadas sawing through the back door. Very typical is the Abstractionist's single, unrepeated knock. And unmistakable is the peremptory knock of historical inevitability, which sets the whole house scurrying.

Usually when we're deep in something, a gentle knock draws us to answer it by its lack of pretension – it can't be much. We open the door to find a rather shabby figure, with a face like the Shadow,

but very benign. We are always surprised to find Marcel Duchamp there; but there he is, inside before we know it, and after his visit – he never stays too long – the house is not quite the same. He first visited the house's "white cube" in 1938 and invented the ceiling – if invention is making us conscious of what we agree not to see, i.e., take for granted. The second time, four years later, he delivered every particle of the interior space to our consciousness – consciousness and the lack of it being Duchamp's basic dialectic.

The ceiling, until he "stood" on it in 1938, seemed relatively safe from artists. It's already taken up by skylights, chandeliers, tracks, fixtures. We don't look at the ceiling much now. In the history of indoor looking up, we rank low. Other ages put plenty up there to look at. Pompeii proposed, among other things, that more women than men looked at the ceiling. The Renaissance ceiling locked its painted figures into geometric cells. The Baroque ceiling is always selling us something other than the ceiling, as if the idea of shelter had to be transcended; the ceiling is really an arch, a dome, a sky, a vortex swirling figures until they vanish through a celestial hole, like a sublime overhead toilet; or it is a luxurious piece of hand-tooled furniture, stamped, gilded, an album for the family escutcheon. The Rococo ceiling is as embroidered as underwear (sex) or a doily (eating). The Georgian ceiling looks like a white carpet, its stuccoed border often stopping short of the angle of ceiling and walls; inside, the central rose, dimpled with shadow, from which descends the opulent chandelier. Often the imagery up there suggests that looking up was construed as a kind of looking down, which gently reverses the viewer into a walking stalactite.

With electric light, the ceiling became an intensely cultivated garden of fixtures, and modernism simply ignored it. The ceiling lost its role in the ensemble of the total room. The Georgian ceiling, for instance, dropped a palisade to the picture molding, extending the roof's domain as a graceful, graduated enclosure. Modern architecture simply ran the blank wall into the blank ceiling and lowered the lid. And what a lid! Its pods, floods, spots, canisters, ducts make it a technician's playground. Up there is yet another undiscovered vernacular, with all the probity of function that cer-

tifies its bizarre arrangements of grid and acoustic tile as *honest* –
that is, unconscious. So our consciousness, which spreads like a
fungus, invents virtues the schlock designer didn't know he/she
had. (The morality of vernacular is our new snobbism.) The only
grace technology bestowed on the ceiling is indirect lighting,
which blooms like lily pads on the overhead pond or which, from
recessed lips, flushes an area of ceiling with the crepuscular
smoothness of an Olitski. Indirect lighting is the color field of the
ceiling. But up there too is a dazzling garden of gestalts. On the
more common regiments of recessed lights, crisscrossing in endless
perceptual drill, we can project the esthetic of the Minimal/Serial
era. Order and disorder smartly lapse into a single idea as we move
around below, raising the issue of an alternative to both.

It must have been an odd feeling to come into the International
Exhibition of Surrealism at the Galerie Beaux-Arts in 1938, see
most of those wild men neatly fitted into their orthodox frames,
then look up expecting the usual dead ceiling and see the *floor*. In
our histories of modern art, we tend to take old photographs as
gospel. They are proof, so we don't grill them as we would any
other witness. But so many questions about those *1,200 Bags of
Coal* don't have answers. Were there really 1,200 bags? (Counting
them is a task to drive Virgos crazy.) Was it the first time an artist
quantified large numbers, thereby giving an event a quota, a con-
ceptual frame? Where did Duchamp get those 1,200 bags? (He
first thought of suspending open umbrellas but couldn't get that
many.) And how could they be full of coal? That would bring the
ceiling – and the police – down on top of him. They must have been
stuffed with paper. How did he attach them all? Who helped him?
You can look through the Duchamp tomes and not be clear about
this. What happened to the ceiling lights? The photographs show
them washing out a cluster of bags here and there. And mystery of
mysteries, why did the other artists let him get away with it?

He had a title of sorts: "Generator–Arbitrator" of the exhibition.
Did he hang the pictures also? Did he conceive them simply as
decor for his gesture? If he were accused of dominating the show,
he could say he took only what no one wanted – the ceiling and a

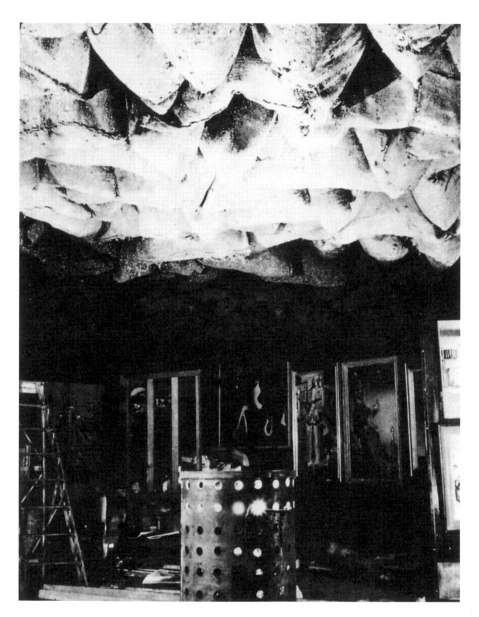

Marcel Duchamp, *1,200 Bags of Coal*, installation view at
"International Exhibition of Surrealism," 1938, New York

little spot on the floor; the accusation would underline his (gigantic) modesty, his (excessive) humility. No one looks at the ceiling; it isn't choice territory – indeed it wasn't (until then) territory at all. Hanging over your head, the largest piccc in the show was unobtrusive physically but totally obtrusive psychologically.

In one of those bad puns he loved, Duchamp turned the exhibition topsy-turvy and "stood you on your head." The ceiling is the floor and the floor, to drive home the point, is the ceiling. For the stove on the floor – a makeshift brazier made from an old barrel, from the looks of it – became a chandelier. The police rightly wouldn't let him put a fire in it, so he settled for a light bulb. Above (below) are 1,200 bags of fuel and below (above) is their consuming organ. A temporal perspective stretches between, at the end of which is an empty ceiling, a conversion of mass to energy, ashes, maybe a comment on history and on art.

This inversion is the first time an artist subsumed an entire gallery in a single gesture – and managed to do so while it was full of other art. (He did this by traversing the space from floor to ceiling. Few remember that on this occasion Duchamp also had his say about the wall: he designed the doors leading in and out of the gallery. He made them – again with reservations from the police – revolving doors, that is, doors that confuse inside and outside by spinning what they trap. This inside-outside confusion is consistent with tilting the gallery on its axis.) By exposing the effect of context on art, of the container on the contained, Duchamp recognized an area of art that hadn't yet been invented. This invention of context initiated a series of gestures that "develop" the idea of a gallery space as a single unit, suitable for manipulation as an esthetic counter. From this moment on, there is a seepage of energy from art to its surroundings. With time the ratio between the literalization of art and mythification of the gallery inversely increases.

Like every good gesture, Duchamp's *Coal Bags* becomes obvious post facto. Gestures are a form of invention. They can only be done once, unless everyone agrees to forget them. The best way of forgetting something is to assume it; our assumptions drop out of sight.

As an invention, however, the gesture's patent is its most distinguishing feature – far more than its formal content, if any. I suppose the formal content of a gesture lies in its aptness, economy, and grace. It dispatches the bull of history with a single thrust. Yet it needs that bull, for it shifts perspective suddenly on a body of assumptions and ideas. It is to that degree didactic, as Barbara Rose says, though the word may overplay the intent to teach. If it teaches, it is by irony and epigram, by cunning and shock. A gesture wises you up. It depends for its effect on the context of ideas it changes and joins. It is not art, perhaps, but artlike and thus has a meta-life around and about art. Insofar as it is unsuccessful it remains a frozen curio, if remembered at all. If it is successful it becomes history and tends to eliminate itself. It resurrects itself when the context mimics the one that stimulated it, making it "relevant" again. So a gesture has an odd historical appearance, always fainting away and reviving.

The ceiling/floor transplant gesture might now be repeatable as a "project." A gesture may be a "young" project; but it is more argumentative and epigrammatic, and it speculates riskily on the future. It calls attention to untested assumptions, overlooked content, flaws in historical logic. Projects – short-term art made for specific sites and occasions – raise the issue of how the impermanent survives, if it does. Documents and photographs challenge the historical imagination by presenting to it an art that is already dead. The historical process is both hampered and facilitated by removing the original, which becomes increasingly fictitious as its afterlives become more concrete. What is preserved and what is allowed to lapse edit the idea of history – the form of communal memory favored at any particular time. Undocumented projects may survive as rumor and attach themselves to the persona of their originator, who is constrained to develop a convincing myth.

Ultimately projects – it seems to me – are a form of historical revisionism waged from a privileged position. That position is defined by two assumptions: that projects are interesting apart from being "art" – that is, they have a somewhat vernacular existence in the world; and that they can appeal to untrained as well

as trained sensibilities. Our architects of personal space, quasi-anthropologists, perceptual revisionists, and mythologists manqués have thus made a break in how the audience is construed. We are now aware of a tentative attempt to contact an audience that postmodernism would like to call up but doesn't quite have the number. This is not the start of a new populism. It is a recognition of a neglected resource, as well as disaffection with the privileged spectator placed by art education in the gallery space. It marks a move away from the modernist conception of the spectator – abused on the basis of presumed incompetence, which is fundamentally a Romantic position.

Gestures have a becoming quality, and some can, retroactively, become projects. There is a project shrewdness implicit in Duchamp's two gallery gestures. They have survived their naughtiness and become historical material, elucidating the gallery space and its art. Yet such is Duchampian charisma that they continue to be seen exclusively in the context of his work. They efficiently keep history at bay, which is one way of remaining modern (Joyce is the literary equivalent). Both the *Coal Bags* and the *Mile of String*, done four years later (1942) for the First Papers of Surrealism show at 551 Madison Avenue, are addressed ambiguously. Are they to be delivered to the spectator, to history, to art criticism, to other artists? To all, of course, but the address is blurred. If pressed to send the gestures somewhere, I'd send them to other artists.

Why did the other artists stand for it not once but twice? Duchamp was very obliging about hanging people up on their worst instincts, especially when those instincts were disguised as ideology. The Surrealists' ideology of shock sometimes manifested itself as exalted public relations. Shock, as the history of the avant-garde shows, is now small-arms equipment. Duchamp, I feel sure, was seen as someone who could generate attention. In delegating him to provide it, the artists were playing little Fausts to an amiable demon. What is the *Mile of String*? At a level so obvious our sophistication immediately disallows it, an image of dead time, an exhibition paralyzed in premature senescence and turned into a grotes-

que horror-movie attic. Both Duchamp's gestures fail to acknowledge the other art around, which becomes wallpaper. Yet the artists' protest (did any of them ever say how they felt?) is preempted. For the harassment of their work is disguised as harassment of the spectators, who have to high-step like hens around it. Two kids (Sidney Janis' boys) played noisy games during the opening from which Duchamp of course absented himself. A connoisseur of expectations of all kinds, Duchamp's interference with the spectator's "set" is part of his malign neutrality. The string, by keeping the spectator from the art, became the one thing he/she remembered. Instead of being an intervention, something between the spectator and the art, it gradually became new art of some kind. What inflicts such harassment is innocuous – 5,280 feet of continuous string. (Again the unverifiable quantification gives a conceptual neatness to the epigram.)

From the photographs, the string reconnoitered the space relentlessly, looping and tautening across each outcrop with demented persistence. It crisscrosses, changes speeds, ricochets back from points of attachment, clusters in knots, wheels new sets of parallaxes with every step, parceling up the space from the inside without the slightest formal worry. Yet it follows the alignment of the room and bays, erratically replicating ceiling and walls. No obliques plunge across the central space, which becomes fenced in, casually quoting the shape of the room. Despite the apparent tizzy of randomness, the room and what is in it determine the string's peregrinations in an orderly enough way. The spectator is harassed. Every bit of space is marked. Duchamp develops the modernist monad: the spectator in his gallery box.

Like all gestures, the string either is swallowed or sticks in history's teeth. It stuck, which means that the formal aspect, if any, hasn't been developed. The string's pedigree borrows from Constructivism and is a cliché in Surrealist painting. The string literalized the space many of the pictures in the exhibition illustrated. This *actualization* of a pictorial convention may be an (unconscious?) precedent for the will to actualize of the late sixties and seventies. To paint something is to recess it in illusion, and

dissolving the frame transferred that function to the gallery space. Boxing up the space (or spacing up the box) is part of the central formal theme of Duchamp's art: containment/inside/outside. From this angle his scattered artifacts align into a rough schema. Is the box – a container of ideas – a surrogate head? And the windows, doorways, and apertures the channels of sense? The two lock into fairly convincing metaphor. The ricocheting string (association tracts?) wraps up the gallery space, modernism's thinking bowl; the *Boîte en Valise* is memory; the *Large Glass* is a mock mechanical apotheosis of aperture and insertion (the insemination of tradition? the creative act?); the doors (open/shut?) and windows (opaque/transparent?) the unreliable senses through which information flows both ways (as it does in puns), dissolving identity as a fixed location. Identity lies scattered around in humorously alienated body parts, which contemplate inside/outside, idea/sensation, consciousness/unconsciousness – or rather, the slash (glass?) between the two. Lacking identity, the parts, the senses, the ideas decompose the paradoxical iconographer gliding around this anthropomorphic shambles. As the *Mile of String* showed, Duchamp is fond of booby traps. He keeps the spectator, whose presence is always voluntary, hung up on his own etiquette, thus preventing him/her from disapproving of his/her own harassment – a source of further annoyance.

Hostility to the audience is one of the key coordinates of modernism, and artists may be classified according to its wit, style, and depth. Like some obvious subjects, it has been ignored. (It's amazing how many modernist historians mime the artist's curatorial shadow, directing traffic around the work.) This hostility is far from trivial or self-indulgent – though it has been both. For through it is waged an ideological conflict about values – of art, of the lifestyles that surround it, of the social matrix in which both are set. The reciprocal semiotics of the hostility ritual are easily read. Each party – audience and artist – is not quite free to break certain taboos. The audience can't get mad, i.e., become philistines. Its anger must be sublimated, already a kind of proto-appreciation. By cultivating an audience through hostility, the

avant-garde gave it the opportunity to transcend insult (second nature to business people) and exercise revenge (also second nature). The weapon of revenge is selection. Rejection, according to the classic scenario, feeds the artist's masochism, sense of injustice, and rage. Enough energy is generated to allow both artist and audience to presume they are fulfilling their social roles. Each remains remarkably faithful to the other's conception of his role – the relationship's most powerful tie. Positive and negative projections volley back and forth in a social charade that wavers between tragedy and farce. One negative exchange is basic: the artist tries to sell the collector on his obtuseness and crassness – easily projected on anyone material enough to want something – and the collector encourages the artist to exhibit his irresponsibility. Once the artist is assigned the marginal role of the self-destructive child, he can be alienated from the art he produces. His radical notions are interpreted as the bad manners expected from superior tradesmen. The militarized zone between artist and collector is busy with guerillas, envoys, double-agents, runners, and both major parties in a variety of disguises as they mediate between principle and money.

At its most serious, the artist/audience relation can be seen as the testing of the social order by radical propositions and as the successful absorption of these propositions by the support system – galleries, museums, collectors, even magazines and house critics – evolved to barter success for ideological anesthesia. The main medium of this absorption is style, a stabilizing social construct if ever there was one. Style in art, whatever its miraculous, self-defining nature, is the equivalent of etiquette in society. It is a consistent grace that establishes a sense of place and is thus essential to the social order. Those who find advanced art without contemporary relevance ignore that it has been a relentless and subtle critic of the social order, always testing, failing through the rituals of success, succeeding through the rituals of failure. This artist/audience dialogue contributes a useful definition of the kind of society we have evolved. Each art licensed a premises where it conformed to and sometimes tested the social structure – concert hall, theater

Marcel Duchamp, *Mile of String*, installation view at
"First Papers of Surrealism," 1942, New York (photo: John D. Schiff)

gallery. Classic avant-garde hostility expresses itself through physical discomfort (radical theater), excessive noise (music), or by removing perceptual constants (the gallery space). Common to all are transgressions of logic, dissociation of the senses, and boredom. In these arenas order (the audience) assays what quotas of disorder it can stand. Such places are, then, metaphors for consciousness and revolution. The spectator is invited into a space where the act of approach is turned back on itself. Perhaps a perfect avant-garde act would be to invite an audience and shoot it.

With postmodernism, the artist and audience are more like each other. The classic hostility is mediated, too often, by irony and farce. Both parties show themselves highly vulnerable to context, and the resulting ambiguities blur their discourse. The gallery space shows this. In the classic era of polarized artist and audience, the gallery space maintained its status quo by muffling its contradictions in the prescribed socio-esthetic imperatives. For many of us, the gallery space still gives off negative vibrations when we wander in. Esthetics are turned into a kind of social elitism – the gallery space is *exclusive*. Isolated in plots of space, what is on display looks a bit like valuable scarce goods, jewelry, or silver: esthetics are turned into commerce – the gallery space is *expensive*. What it contains is, without initiation, well-nigh incomprehensible – art is *difficult*. Exclusive audience, rare objects difficult to comprehend – here we have a social, financial, and intellectual snobbery which models (and at its worst parodies) our system of limited production, our modes of assigning value, our social habits at large. Never was a space, designed to accommodate the prejudices and enhance the self-image of the upper middle classes, so efficiently codified.

The classic modernist gallery is the limbo between studio and living room, where the conventions of both meet on a carefully neutralized ground. There the artist's respect for what he has invented is perfectly superimposed on the bourgeois desire for possession. For a gallery is, in the end, a place to sell things – which is O.K. The arcane social customs surrounding this – the stuff of social comedy – divert attention from the business of assigning material value to that which has none. Here the hostile artist is a

commercial *sine qua non*. By gassing up his self-image with obsolete romantic fuel, he provides his agent with the means to separate artist and work, and so facilitate its purchase. The artist's irresponsible persona is a bourgeois invention, a necessary fiction to preserve some illusions from too uncomfortable an examination – illusions shared by artist, dealer, and public. It is hard now to avoid the conclusion that late modernist art is inescapably dominated by the assumptions – mostly unconscious – of the bourgeoisie; Baudelaire's vicious and noble preface *To the Bourgeoisie* for the Salon of 1846 is the prophetic text. Through reciprocating paradoxes the idea of free enterprise in art goods and ideas supports social constants as much as it attacks them. Attacking them has indeed become a permissible charade from which both parties emerge relatively satisfied.

This may be why the art of the seventies locates its radical notions not so much in the art as in its attitudes to the inherited "art" structure, of which the gallery space is the prime icon. The structure is questioned not by classic resentment but by project and gesture, by modest didacticism and phasing of alternatives. These are the hidden energies of the seventies; they present a low-lying landscape which is traversed by ideas deprived of absolutes and powered by low-grade dialectics. No peaks are forced up by irreconcilable pressures. The landscape levels off partly because the genres involved in mutual recognition and avoidance (post-Minimalism, Conceptualism, Color Field, Realism, etc.) are nonhierarchical – one is as good as another. The democracy of means contributed by the sixties is now extended to genres, which in turn reflect a demythified social structure (the "professions" now carry fewer rewards and diminished prestige). The sixties still headline most people's perception of the seventies. Indeed one of the "properties" of seventies art is the failure of sixties critics to look at it. Measuring the seventies by the sixties is faulty but unavoidable (an artist's new phase is always judged in relation to the one previous). Nor does the skipped decade theory help – the fifties revival turned out to be a bummer.

Seventies art is diverse, made up of nonhierarchical genres and

highly provisional – indeed unstable – solutions. Major energies no longer go into formal painting and sculpture (young artists have a fairly good nose for historical exhaustion) but into mixed categories (performance, post-Minimal, video, tuning the environment), which present more temporary situations involving an inspection of consciousness. When necessary, seventies art crosses media in a gentle, nonpolemical way – understatement being a characteristic of its low profile. It tends to deal with what is immediately present to the senses and the mind, and so presents itself as intimate and personal. Thus it often appears narcissistic, unless this is understood as a mode of locating the boundary where a person "ends" and something else begins. It is not in search of certainties, for it tolerates ambiguity well. Its intimacies have a somewhat anonymous cast since they turn privacy inside out to make it a matter of public discourse – a seventies form of distancing. Despite this personal focus, there is no curiosity about matters of identity. There is great curiosity about how consciousness is constructed. Location is a key word. It telescopes concerns about *where* (space) and *how* (perception). *What* is perceived, one gathers from genres as widely removed as Photo-Realism and post-Minimalism, is not as important (though a dwarf called iconography schlepps around knocking at every door). Most seventies art seems to attempt a series of verifications on an ascending scale: physical (out there); physiological (internal); psychological; and, for want of a better word, mental. These roughly correspond with available genres. The correlatives are personal space, perceptual revisions, exploration of time conventions, and silence.

These verifications locate a body, mind, and place that can be *occupied,* or at least partly tenanted. If fifties man was a Vitruvian survivor and sixties man composed of alienated parts held together by systems, seventies man is a workable monad – figure and place, a transposition of figure and ground into a quasi-social situation. Seventies art does not reject the consequences of fifties and sixties art, but some basic attitudes have changed. The sixties audience is rejected by seventies art. Often there is an attempt to communicate with an audience that hasn't been interfered with

by art, thus dislodging the wedge that "art" has driven between perception and cognition. (The growth of alternative spaces across the country outside the formal museum structure is part of this – a change of audience, location, and context that makes it possible for New York artists to do what they can't do in New York.) Seventies art remains troubled by history, yet so much of it is temporary it rejects the historical consciousness. It questions the system through which it presents itself, yet most of it passed through that system. Its makers are socially concerned but politically ineffective. Some of the dilemmas suppressed during the avant-garde era have come home to roost, and seventies art is working through them in its rather elusive way.

With postmodernism, the gallery space is no longer "neutral." The wall becomes a membrane through which esthetic and commercial values osmotically exchange. As this molecular shudder in the white walls becomes perceptible, there is a further inversion of context. The walls assimilate; the art discharges. How much can the art do without? This calibrates the degree of the gallery's mythification. How much of the object's eliminated content can the white wall replace? Context provides a large part of late modern and postmodern art's content. This is seventies art's main issue, as well as its strength and weakness.

The white wall's apparent neutrality is an illusion. It stands for a community with common ideas and assumptions. Artist and audience are, as it were, invisibly spread-eagled in 2-D on a white ground. The development of the pristine, placeless white cube is one of modernism's triumphs – a development commercial, esthetic, and technological. In an extraordinary strip-tease, the art within bares itself more and more, until it presents formalist end-products and bits of reality from outside – "collaging" the gallery space. The wall's content becomes richer and richer (maybe a collector should buy an "empty" gallery space). The mark of provincial art is that it has to include too much – the context can't replace what is left out; there is no system of mutually understood assumptions.

The spotless gallery wall, though a fragile evolutionary product

of a highly specialized nature, is impure. It subsumes commerce and esthetics, artist and audience, ethics and expediency. It is in the image of the society that supports it, so it is a perfect surface off which to bounce our paranoias. That temptation should be resisted. The white cube kept philistinism at the door and allowed modernism to bring to an endpoint its relentless habit of self-definition. It hothoused the serial jettisoning of content. Along the way numerous epiphanies were purchased, as epiphanies can be, by suppression of content. If the white wall cannot be summarily dismissed, it can be understood. This knowledge changes the white wall, since its content is composed of mental projections based on unexposed assumptions. The wall *is* our assumptions. It is imperative for every artist to know this content and what it does to his/her work.

The white cube is usually seen as an emblem of the estrangement of the artist from a society to which the gallery also provides access. It is a ghetto space, a survival compound, a proto-museum with a direct line to the timeless, a set of conditions, an attitude, a place deprived of location, a reflex to the bald curtain wall, a magic chamber, a concentration of mind, maybe a mistake. It preserved the possibility of art but made it difficult. It is mainly a formalist invention, in that the tonic weightlessness of abstract painting and sculpture left it with a low gravity. Its walls are penetrable only by the most vestigial illusionism. Was the white cube nurtured by an internal logic similar to that of its art? Was its obsession with enclosure an organic response, encysting art that would not otherwise survive? Was it an economic construct formed by capitalist models of scarcity and demand? Was it a perfect technological shrinkage resulting from specialization or a Constructivist hangover from the twenties that became a habit, then an ideology? For better or worse it is the single major convention through which art is passed. What keeps it stable is the lack of alternatives. A rich constellation of projects comments on matters of location, not so much suggesting alternatives as enlisting the gallery space as a unit of esthetic discourse. Genuine alternatives cannot come from within this space. Yet it is the not ignoble symbol for the preservation of what society finds obscure, unimportant, and useless. It has

incubated radical ideas that would have abolished it. The gallery space is all we've got, and most art needs it. Each side of the white cube question has two, four, six sides.

Is the artist who accepts the gallery space conforming with the social order? Is discomfort with the gallery discomfort with art's etiolated role, its cooption and vagabond status as a refuge for homeless fantasies and narcissistic formalisms? During modernism, the gallery space was not perceived as much of a problem. But then, contexts are hard to read from the inside. The artist was not aware he was accepting anything except a relationship with a dealer. And if he saw beyond it, accepting a social context you can do nothing about shows a lot of common sense. Most of us do exactly that. Before large moral and cultural issues, the individual is helpless but not mute. His weapons are irony, rage, wit, paradox, satire, detachment, skepticism. A familiar kind of mind comes into focus here – restless, self-doubting, inventive about diminishing options, conscious of void, and close to silence. It is a mind with no fixed abode, empirical, always testing experience, conscious of itself and thus of history – and ambiguous about both.

This Faustian composite more or less fits numerous modernists from Cézanne to de Kooning. Such figures sometimes convince you that mortality is a disease to which only the most gifted are susceptible, and that the privileged perception resides in the psyche that can maximize the contradictions inherent in existence. Such a figure, whatever its symbolist or existential pedigree, suffers from a romantic infection with the absolute; aching for transcendence, it is detained in process. This figure, which has generated most of modernism's myths, has done great service; but it is a period figure that might well be fully retired. For now, contradiction is our daily vernacular, our attitudes to it a passing anger (a short-term synthesis?), humor, and a kind of bemused shrug. We tolerate other people's necessary anesthesia, as they do ours. Whoever bends on him/herself the rays of contradiction becomes not a hero but the vanishing point in an old picture. In our own interests, we are hard on the art that precedes us. We see not so much the art as an emblem for attitudes, contexts, and myths

unacceptable to us. Finding a code to reject this art allows us to invent our own.

Modernism has also provided us with another archetype: the artist who, unaware of his minority, sees the social structure as alterable through art. A believer, he is concerned not so much with the individual as with the race; is, in fact, a kind of discreetly authoritarian socialist. The rational, reformist urge refers to the age of reason and is nourished on the utopian habit. It also has a strong mystical/ideal component that places heavy responsibilities on the function of art. This tends to reify art and turn it into a device exactly measuring its dissociation from social relevance. So both archetypes alienate art from the social structure with opposite intentions. Both are old Hegelian doubles partners, and they are rarely pure. You can pick your own pairings: Picasso and Tatlin; Soutine and Mondrian; Ernst and Albers; Beckmann and Moholy-Nagy.

But the history of utopianism in modernism is rather splendid. The magnitude of the individual's presumption is clear to us, but it is also clear to him. So while aligning himself with mystical energies, he also courts the rationalities of design, an echo of the Design of the Creator that the artist-creator intends to correct. At the end of an era it is easy to be funny about such ambitions. We tend to patronize high ideals after their failure. But the idealist/utopians are dismissed too easily by our New York habit of mind – in which the myth of the individual as a republic of sensibility is firmly set. European utopians – who can forget Kiesler moving like a Brownian particle through the New York milieu? – don't do well here. Coming from a different structure, their ideas don't play in a society that reshuffles its classes every second generation. But a kind of European mind could think about social problems and art's transforming powers very well. Now we ask some of the same questions about the missing audience and where it has gone. Most of the people who look at art now are not looking at art; they are looking at the idea of "art" they carry in their minds. A good piece could be written on the art audience and the educational fallacy. We seem to have ended up with the wrong audience.

What makes artists interesting is the contradictions they choose to edit their attention – the scissors they invent to cut out their self-image. The utopian artist/planner finds that his individuality, which must conform to the social structure he envisions, breaks the rule of such conformity by its individualism. As Albert Boime wrote (*Arts*, Summer '70): ". . . Mondrian opposes subjectivity on the grounds that individualism leads to disharmony and conflict, and interferes with the creation of a 'harmonious material environment' (i.e., a universally objective and collective outlook). At the same time, he is preoccupied with artistic originality because in his view only the uniquely gifted individual could discover the universal order. He therefore urged all artists to detach themselves 'from the majority of the people.' " For such artists, intuition must be thoroughly rationalized. Disorder, covertly suppressed in Mondrian's clear surfaces and edges, is manifest in the whole arbitrary nature of his choices. As Boime says, "Mondrian achieved equilibrium only after innumerable complex steps, and the multiplication of decisions betrays his personality." So what can one say when one enters Mondrian's room (which he himself never entered, since his 1926 sketch for a *Salon de Madame B. à Dresden* was not made up until 1970 [for an exhibition at Pace Gallery])?

We are in a proposition that conjugates basic needs – bed, desk, shelf – with principles of harmony derived from the natural order. "Precisely on account of its profound love for things," wrote Mondrian, "non-figurative art does not aim at rendering them in their particular appearance." But Mondrian's room is as clearly based on nature as if it were lined with trees. The panels are so adjusted that they advance and recede within a narrow compass. The room breathes, as it were, through the walls. This is enhanced by its perspective, producing the obliques Mondrian formally proscribed. The room is not so much anthropomorphic as *psyche-morphic*. Its powerful ideas coincide with mental contours perfectly sensed by Mondrian: "In removing completely from the work all objects, the world is not separated from the spirit, but is on the contrary *put into a balanced opposition* with the spirit, since the one and the other are purified. This creates a perfect unity between

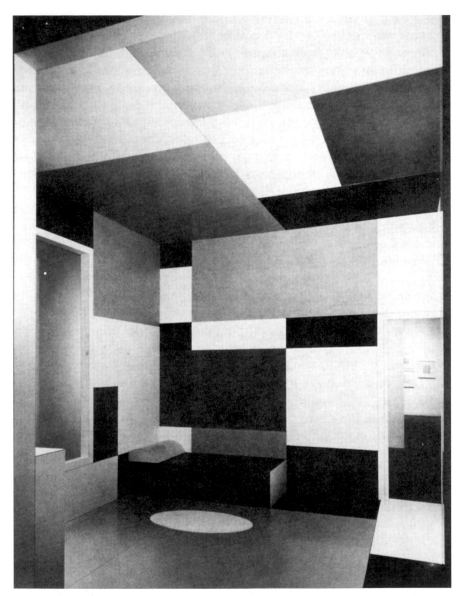

Piet Mondrian, *Salon de Madame B. à Dresden,*
installation view (after the artist's drawing of 1926), 1970,
courtesy The Pace Gallery, New York (photo: Ferdinand Boesch)

the two opposites." Since the walls, despite Mondrian's objections to Cubism's realism, represent a sublimated nature, the occupant is similarly encouraged to transcend his own brute nature. In this space, the grossness of the body seems inappropriate; from this room burps and farts are exiled. Through systems of abutment and slide, rectangle and square define a space that places one inside a Cubist picture; the occupant is synthesized into a coefficient of order whose motion is in consonance with the rhythms enclosing him or her. The floor – which contains an uncharacteristic oval (a rug?) – and ceiling add their vertical pressures. It's a marvelous place to visit.

The vision is not hermetic. Windows allow for discourse with the outside. Random process – what you see through the window – is precisely framed. Is this formally acknowledged in the small bite the lower left corner of the window takes out of a black square (much as Texas bites off a piece of Arkansas)? For all its sober idealist program, the room reminds me that Mondrian liked to dance (though his dancing, which was terrible, was based more on extracting pleasure from the programmed movements while happily coupled than on wild abandon). Mondrian's room proposed an alternative to the white cube that modernism ignored: "By the unification of architecture, sculpture and painting, a new plastic reality will be created. Painting and sculpture will not manifest themselves as separate objects, nor as 'mural art' which destroys architecture itself, nor as 'applied' art, but *being purely constructive* will aid the creation of a surrounding not merely utilitarian or rational but also pure and complete in its beauty."

Duchamp's altered rooms – ironic, funny, fallible – still accepted the gallery as a legitimate place for discourse. Mondrian's spotless room – a shrine to spirit and Madame Blavatsky – attempted to introduce a new order that would make the gallery dispensable. The two counterposed categories suggesting a comic slapstick not unknown to modernism: the scruffy and the clean, the bacterial and the hygienic, the sloppy and the precise. Part of the grand irony presiding over such dialectical separations is their frequent mimicking of each other in disguises too elaborate to remove here.

Mondrian and Malevich shared a mystical faith in art's trans-forming social power. Both men's ventures outside the picture plane were tentative; both were politically innocent. Tatlin, in contrast, was all social involvement, full of great schemes and energy.

One figure took Tatlin's radical social program and Malevich's formal idealism and negotiated between them to produce exhibitions that could – and did – alter the public mind. Lissitzky did so through an inspiration that doesn't seem to occur to idealists and radical social planners. He acknowledged the bystander, who became the involved spectator. Lissitzky, our Russian connection, was probably the first exhibition designer/preparator. In the process of inventing the modern exhibition, he also reconstructed the gallery space – the first serious attempt to affect the context in which modern art and the spectator meet.

IV. The Gallery as a Gesture

*The value of an idea is proved by its power to organize
the subject matter.* Goethe

From the '20s to the '70s, the gallery has a history as distinct as
that of the art shown in it. In the art itself, a trinity of changes
brought forth a new god. The pedestal melted away, leaving the
spectator waist-deep in wall-to-wall space. As the frame dropped
off, space slid across the wall, creating turbulence in the corners.
Collage flopped out of the picture and settled on the floor as easily
as a bag lady. The new god, extensive, homogeneous space, flowed
easily into every part of the gallery. All impediments except "art"
were removed.

 No longer confined to a zone around the artwork, and impreg-
nated now with the memory of art, the new space pushed gently
against its confining box. Gradually, the gallery was infiltrated with
consciousness. Its walls became ground, its floor a pedestal, its cor-
ners vortices, its ceiling a frozen sky. The white cube became art-
in-potency, its enclosed space an alchemical medium. Art became
what was deposited therein, removed and regularly replaced. Is
the empty gallery, now full of that elastic space we can identify
with Mind, modernism's greatest invention?

 To present the content of that space leads to Zen questions:
When is a Void a plenum? What changes everything and remains
itself unchanged? What has no place and no time and yet is peri-
od? What is everywhere the same place? Once completed by the
withdrawal of all apparent content the gallery becomes a zero
space, infinitely mutable. The gallery's implicit content can be
forced to declare itself through gestures that use it whole. That
content leads in two directions. It comments on the "art" within,
to which it is contextual. And it comments on the wider context –
street, city, money, business – that contains it.

First gestures have a quality of blundering, indicating an imperfect consciousness. Yves Klein's gesture at the Galerie Iris Clert on April 28, 1958, may have been in search of ". . . a world without dimension. And which has no name. To realize how to enter it, One encompasses it all. Yet it has no limits." But its implications for the gallery space were profound. It was a remarkably complete event, as complete as his image of himself as mystic and angel eating the air, promise-crammed. He arrived (in his famous photograph) in free-fall from a second-floor window. From judo he learned how to land without injury. What he really alighted upon was, perhaps, the rather complacent pool of French painterliness. Time gives method to his madness and illustrates how modernism recreates, from photographs, some of its most influential touchstones.

For avant-garde gestures have two audiences: one which was there and one – most of us – which wasn't. The original audience is often restless and bored by its forced tenancy of a moment it cannot fully perceive – and that often uses boredom as a kind of temporal moat around the work. Memory (so disregarded by modernism which frequently tries to remember the future by forgetting the past) completes the work years later. The original audience is, then, in advance of itself. We from a distance know better. The photographs of the event restore to us the original moment, but with much ambiguity. They are certificates that purchase the past easily and on our terms. Like any currency, they are subject to inflation. Aided by rumor, we are eager to establish the coordinates within which the event will maximize its historical importance. We are thus offered an irresistible opportunity to partake in creation of a sort.

But to return to Yves Klein suspended over the pavement like a gargoyle. Klein's gallery gesture had a trial run at the Galerie Colette Allendy in Paris in 1957. He left one small room bare to, as he said, "testify to the presence of pictorial sensitivity in a state of primary matter." That "presence of pictorial sensitivity" – the empty gallery's content – was, I believe, one of the most fatal insights in postwar art. For his major gesture at Iris Clert's, "He

painted the façade on the street blue," wrote Pierre Descargues in a Jewish Museum catalogue, "served blue cocktails to the visitors, tried to light up the Luxor obelisk in the Place de la Concorde, and hired a Garde Republicaine in uniform to stand at the entrance to the gallery. Inside he had removed all the furniture, painted the walls white, whitened one showcase which contained no object." The exhibition was called *The Void*, but its longer title, developing the previous year's idea, is more instructive: "The isolation of sensibility in a state of primary matter stabilized by pictorial sensibility." An early visitor was John Coplans, who thought it odd.

On opening night, three thousand people came, including Albert Camus, who wrote in the book: "With the Void. Full Powers." While offering itself as site and subject, the gallery primarily hosted a transcendent gesture. The gallery, the locus of transformation, became an image of Klein's mystical system – the grand synthesis derived from the symbolists in which *azur* (International Klein Blue) became the transubstantiating device – the symbol, as it was for Goethe, of air, ether, spirit. In a conceit reminiscent of Joseph Cornell, Klein had touched space through the sputnik flight in 1957, which he surrounded with a mystical halo. Klein's ideas were a nutty but oddly persuasive mix, stirring mysticism, art, and kitsch in the same pot. His art raises again, as the work of successful charismatics does, the problem of separating the objects of art from the relics of a cult. Klein's work had generosity, utopian wit, obsession, and its share of transcendence. In that apotheosis of communication that becomes communion, he offered himself to others and others consumed him. But like Piero Manzoni, he was a prime mover, very European, rife with metaphysical disgust at the ultimate bourgeois materialism: the hoarding of life as if it were a possession on the order of a sofa.

Outside blue, inside the white void. The gallery's white walls are identified with spirit, filmed over with "pictorial sensitivity." The blanched display case is an epigram on the idea of exhibition; it raises the prospect of serial contexts (in the empty gallery, the display case contains nothing). The double mechanism of display (gallery and case) reciprocally replaces the missing art with itself.

To insert art into gallery or case puts the art in "quotation marks." By making art an artificiality within the artificial, it suggests that gallery art is a trinket, a product of the boutique. What is now called the support system (a phrase that became popular with the maintenance of life in space) is becoming transparent. As time goes by, Klein's gesture becomes more successful; history obligingly curves into an echo chamber.

The theatrics – the Garde, the cocktails (another comment on inside/outside?), the Luxor obelisk inscribing the void above like a wrinkled pencil (this one didn't work out) – brought that attention without which a gesture is stillborn. This was the first of several gestures that use the gallery as a dialectical foil. These gestures have a history and a provenance: each tells us something about the social and esthetic agreements that preserve the gallery. Each uses a single work to draw attention to the gallery's limits, or contains it in a single idea. As the space that socializes those products of a "radical" consciousness, the gallery is the locus of power struggles conducted through farce, comedy, irony, transcendence, and, of course, commerce. It is a space that rides on ambiguities, on unexplored assumptions, on a rhetoric that, like that of its parent, the museum, barters the discomfort of full consciousness for the benefits of permanence and order. Museums and galleries are in the paradoxical position of editing the products that extend consciousness, and so contribute, in a liberal way, to the necessary anesthesia of the masses – which goes under the guise of entertainment, in turn the laissez-faire product of leisure. None of this, I might add, strikes me as particularly vicious, since the alternatives are rampant with their own reformist hypocrisy.

In proper teleological fashion, Klein's gesture produced a response at the same gallery, Iris Clert's, in October 1960, the same month that the New Realists formally composed themselves as a group. Klein's *Void* was filled with Arman's *Le Plein*, an accumulation of garbage, detritus, waste. Air and space were evicted until, in a kind of reverse collage, the trash reached critical mass by pressing against the walls. It could be seen pressing against the window and door. As a gesture it lacks the ecstasy of Klein's tran-

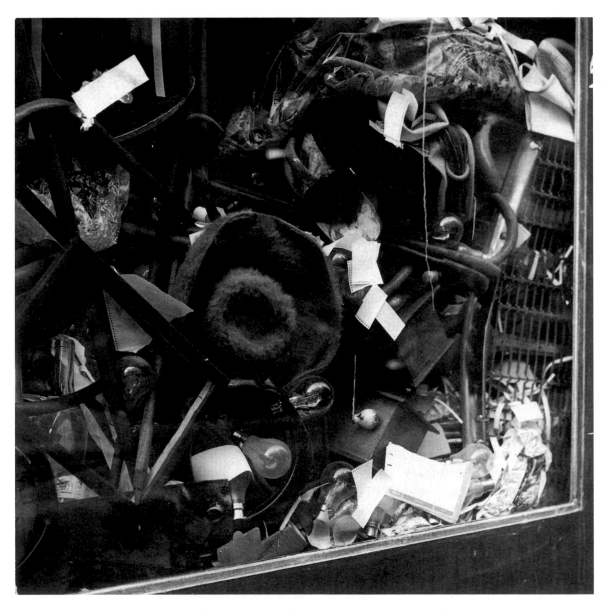

Armand P. Arman, *Le Plein*, 1960 Galerie Iris Clert, Paris. View of the gallery window. Reproduced by permission.

scendent nostomania. More mundane and aggressive, it uses the gallery as a metaphorical engine. Stuff the transforming space with refuse and then ask it, grotesquely overloaded, to digest *that*. For the first time in the brief history of gallery gestures, the visitor is *outside* the gallery. Inside, the gallery and its contents are now as inseparable as pedestal and artwork. In all this, there is a bit of what Arman himself called a tantrum. Modernism with its rigorous laws often exasperates its own children whose very disobedience acknowledges parental rule. By rendering the gallery inaccessible, and reducing the excluded visitor to peering through the window at the junk within, Arman initiated not just divorce proceedings, but a major schism.

Why should the early gallery gestures have come from the New Realists in the late '50s and the '60s? Infused with social consciousness, their work was coming to an influential denouement. But it was undercut by international art politics. "It was the tough luck of the Parisian avant garde," wrote Jan van der Marck, "baptized by Yves Klein's presentation of the Void at Iris Clert's in Paris in 1958 and institutionally enshrined in Nieuwe Realisten at the Haags Gemeentenmuseum in June 1964, to coincide with the demise of Paris and the ascendancy of New York. In the struggle for international attention 'Frenchness' became a liability, and young American artists believed that the tradition from which it drew was bankrupt." Americans capitalized on their idea of the raw in contrast to Europe's haute cuisine. Yet the New Realists' perception of the gallery's politics was more astute. The early New Realist gestures, apart from Klein's marvelous hocus-pocus, have a savage edge. But then the European gallery has a political history dating from at least 1848. It is by now as ripe as any symbol of European commerce that may present itself to the jaundiced eye. Even the most amiable of New Realist gestures has a hard center. In Stockholm at the Addi Kopcke Gallery in 1961, Daniel Spoerri arranged for the dealer and his wife, Tut, to sell groceries just bought from the store at "the current market price of each article." Stamped "CAUTION: WORKS OF ART," each item bore Spoerri's "certifying signature." Was this parody of commerce visible to the

dealer? Could it have happened on the Milan/Paris/New York axis?

The New York gesture that charged every particle of the gallery space had a more amiable complexion. One of the sights of the '60s was entering the Castelli Gallery in 1966 and seeing Ivan Karp shepherding with a pole Andy Warhol's silver pillows as they floated and drifted in that historic uptown space at 4 East 77th Street. Every part of the space was active, from the ceiling – against which the pillows bumped – to the floor where they occasionally sank, to be agitated again. This discrete, changing, and silent artwork mocked the kinetic urgencies buzzing and clanking in the galleries of the day, laid claim to pedigree (allover space) and united happiness with didactic clarity. Visitors smiled as if relieved of a deep responsibility. That this work was not a fluke was clear from the *Cow Wallpaper* papering a small adjacent room. From the heroic '40s and '50s, phrases like Harold Rosenberg's "apocalyptic wallpaper" still hung in the air. Reducing the prime symbol of energy to wallpaper – etiolated further by repetition- brought matters of high seriousness into the precincts of interior decoration, and vice versa.

Warhol's astute relation to wealth, power, and chic is deeply implicated in the fictions of American innocence – very different from the European's instinctive ability to locate the enemy. American innocence is sustained by a variety of delusions which recent successful avant-gardes have tended to share. Arman's assassination of a white Mercedes attacked a materialism very different from that of the Americans. Anarchic gestures in America do not do well. They tend to refute the official optimism born of hope. Accumulating below the threshold of good form and acceptable style, they tend to be forgotten. I think of Tosun Bayrak's "banged-up dirty white automobile on Riverside Drive in New York City, stuffed . . . full of animal guts . . . a bull's head peering out the front window . . . left . . . until the neighborhood stank" (Therese Schwartz).

Whatever its excesses, the American avant-garde never attacked the *idea* of a gallery, except briefly to promote the move to the land which was then photographed and brought back to the gallery to

93

be sold. Materialism in America is a spiritual thirst buried deep within a psyche that wins its objects from nothing and will not give them up. The self-made man and the man-made object are cousins. Pop art recognized this. Its blurred fusion of indulgence and criticism reflected the bourgeois' material pleasures enhanced by a little spiritual thirst. The satiric impulse in American art, apart from Peter Saul, Bernard Aptheker, and a very few others, remains without its object, somewhat unfocused and insecure as to the nature of its enterprise. In a country where the social classes are imperfectly defined, and the rhetoric of democracy makes their separation suspect, criticism of material success often appears as a form of sophisticated envy. For the artist, of course, the avatar of all this is his or her product. It tends to be the agent of his or her alienation, to the degree that it enters the social matrix. In an operation that never fails, it has its meaning lifted. The site of that operation is the gallery. So Arman's visitor, denied entry outside the stuffed Galerie Iris Clert, may recognize some of the artist's anger in his own.

The excluded visitor, forced to contemplate not art but the gallery, became a motif. In October 1968, the European artist most sensitive to the politics of the gallery space, Daniel Buren, sealed off the Galleria Apollinaire in Milan for the duration of the exhibition. He glued vertical white and green stripes on fabric over the door. Buren's esthetic is generated by two matters: stripes and their location. His theme is encouraging the world's systems to vocalize themselves through his constant stimulus, his catalyst, monogram, signature, sign. The stripes neutralize art by depletion of content. As a sign of art they become an emblem of consciousness – art was here. "And what does art say?" the situation asks. As a sign, the stripes represent a recognizable aspect of European avant-gardism: a cool intelligence, politically sophisticated, commenting on the social agreement that allows art to be made and yet demeans it. So the stripes bring to the door of the gallery not art so much as a monologue in search of an argument.

This gesture was preceded, as Yves Klein's was, by a modified trial run. In April of the same year, at the Salon de Mai held at the

Museum of Modern Art in Paris, Buren offered his "Proposition Didactique." One wall of an empty gallery was covered with green and white stripes. Stripes were placed on 200 billboards around the city. Outside the gallery, two men with striped billboards paraded. One is reminded of Gene Swenson walking up and down outside the Museum of Modern Art in the early '70s, carrying a sign emblazoned only with a question mark. (Swenson and Gregory Battcok were the two New York figures with a political intelligence comparable to that of the New Realists. No one took them very seriously. Life, however, did; they both died tragically.)

Buren's Milan stripes closed the gallery in much the same way that public health officials close infected premises. The gallery is received as a symptom of a disordered body social. The toxic agent isolated within is not so much art as what – in every sense – contains it. Art is also contained by another social agreement (in my opinion external to it) called style. The stripes, which identify a personality with a motif and a motif with art, imitate the way style works. Style is constant, so Buren's constant stimulus is a grotesque parody of it. Style, we know, extracts from the work an essence which is negotiable cross-culturally. Through style, as Andre Malraux demonstrated, all cultures talk to you. This idea of a formalist Esperanto goes with the placeless white cube. Formalist art in placeless galleries stands, like the medieval church, for a system of commerce and belief. Insofar as style succeeded in identifying meaning with itself, the work's content was devalued. This connoisseurship facilitated the assimilation of the work, no matter how bizarre, into the social matrix. Buren understands perfectly this form of socialization. "How can the artist contest society," he asks, "when his art, all art, 'belongs' objectively to that society?"

Indeed much of the art of the late '60s and the '70s had this theme: How does the artist find another audience, or a context in which his or her minority view will not be forced to witness its own co-optation? The answers offered – site-specific, temporary, nonpurchasable, outside the museum, directed toward a nonart audience, retreating from object to body to idea – even to invisibility – have not proved impervious to the gallery's assimilative

appetite. What did occur was an international dialogue on perception and value-systems – liberal, adventurous, sometimes programmatic, sometimes churlish, always antiestablishment and always suffering from the pride that demands the testing of limits. The intellectual energy was formidable. At its height it seemed to leave no room for artists who were just good with their hands – inviting subsequent fictions of dumbness and a return to the canvas. Artists' revolutions, however, are bounded by the inexorable rules that include those implicit in the empty gallery. There was an exhilarating run of insights into the cycle of production and consumption: this paralleled the political troubles at the end of the '60s and the beginning of the '70s. At one point, it seemed as if the gallery's walls were turning to glass. There were glimpses of the world outside. The gallery's insulation of art from the present while conveying it to the future seemed for a moment deeply compromised. Which brings us back to Buren's closed doors. ". . . the artist who creates silence or emptiness must produce something dialectical: a full void, an enriching emptiness, a resonating or eloquent silence," wrote Susan Sontag in "The Esthetics of Silence." "Art" forces the void behind the closed door to speak. Outside, art is saved and refuses to go in.

This conceptualization of the gallery reached its ultimate point a year later. In December 1969, in the *Art & Project Bulletin #17* (its pages were a floating artists' space), Robert Barry wrote, "during the exhibition the gallery will be closed." This idea was realized at the Eugenia Butler Gallery in Los Angeles the following March. For three weeks (March 1-21) the gallery was closed; outside, the same legend was posted. Barry's work has always employed scanty means to project the mind beyond the visible. Things are there but barely seen (nylon string): process is present but cannot be sensed (magnetic fields): attempts are made to transfer ideas without words or objects (mentalism). In the closed gallery, the invisible space (dark? deserted?), uninhabited by the spectator or the eye, is penetrable only by mind. And as the mind begins to contemplate it, it begins to ruminate about frame and base and collage – the three energies that, released within its pristine whiteness, thor-

oughly artified it. As a result, anything seen in that space involves a hitch in perception, a delay during which expectation – the spectator's idea of art – is projected and seen.

This doubling of the senses – advocated by such disparate characters as Henry David Thoreau and Marcel Duchamp – became in the '60s a period sign, a perceptual stigma. This doubling enables sight, as it were, to see itself. "Seeing sight" feeds on emptiness; eye and mind are reflected back to engage their own process. While this can produce interesting forms of perceptual narcissism and quasi-blindness, the '60s were more concerned with eroding the traditional barricades set up between perceiver and perceived, between the object and the eye. Vision would then be able to circulate without the impediment of traditional conventions. Such a perceptual Utopia was consonant with the radical sensory transformations of '60s culture. In galleries, its most cogent expression was in Les Levine's "White Sight" at the Fischbach Gallery in 1969. On entering the gallery the spectator, deprived of color and shadow by two high-intensity monochromatic sodium vapor lights, attempted to recreate the space. Other viewers became visual cues, points of reference from which to read the space. The audience thus became an artifact. Without sight, the audience turned back on itself, attempted to develop its own content. This intensified the experience of being alone in any empty white gallery, in which the act of looking, coached by expectation, becomes a kind of instant artifact. So, to return to the white space, the twin contexts of anticipation – the gallery and the spectator's mind – are fused in a single system, which could be tripped.

How could this be done? The minimal adventure reduced the stimulus and maximized its resonance within the system. In this exchange, metaphor died (this was minimalism's major contribution, shutting the door on modernism). The containing box, the white cube, was forced to declare some of its hidden agenda, and this partial demythification had considerable consequences for the installation idea. Another response was to literalize life or nature within the gallery; e.g., Jannis Kounellis' horses, intermittently occupying art spaces from 1969 on; Newton Harrison's doomed

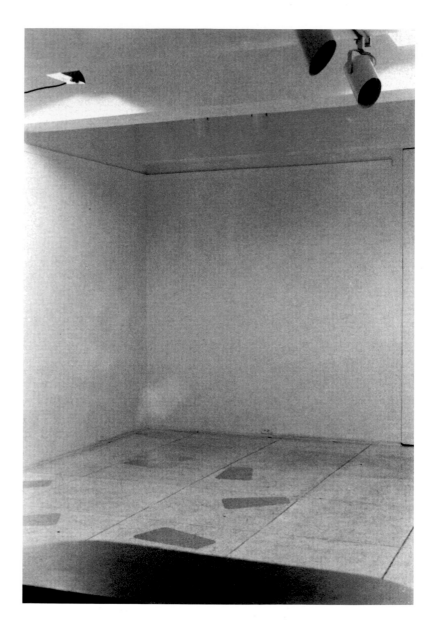

Les Levine, *White Sight,* 1969, Fischbach Gallery. Photo: Les Levine.
Reproduced by permission.

fish at the Hayward Gallery in 1971. Any transformation that occurred at these extreme points was more alchemical than metaphorical. Transformation became the spectator's rather than the artist's role. Indeed the artist's role became a kind of *de-creation*, providing a stimulus for the spectator to take into his or her art-making system (art as the opiate of the upper middle classes).

In transforming what is present in the gallery – which resists transformation – we are becoming the creator, painlessly. In that process we are ourselves artified, alienated from the work even as we transform it. Spectators in a gallery begin to look like Kounellis' horses. The confusion between the animate and inanimate (object and spectator) reverses the Pygmalion myth: the art comes alive and refines the spectator. Consciousness is the agent and medium. So the possession of a higher consciousness becomes a license to exploit its evolutionary inferiors. In such ways does the gallery situation reflect the real world outside it. The confusion of art and life invites gestures that would push it to the extreme – a murder in a gallery, perhaps? Is it art? Would that be a legal defense? Would Hegel testify to its dialectical relation to the gallery space? Would Jacques Vache be called as a witness for the defense? Could the work be sold? Would the photo-documentation be the real work? And all the time, in Barry's empty gallery, the meter ticks; someone is paying the rent. An enlightened dealer is losing money to help make points about the space that sells things. It is as if a Bedouin were starving his horse or an Irishman suffocating his pig. In Barry's closed space, over the three weeks, the space stirs and mutters; the white cube, now a brain in a bowl, does its thinking.

These gestures seek, in short, transcendence, exclusion through excess, isolation through dialectic and through mental projection. They found their opposite in a work done, accommodatingly enough, in the southern hemisphere. Lucy R. Lippard in her *Six Years: The Dematerialization of the Art Object from 1966 to 1972* (one of the great books of the '70s) describes it thus: "The Rosario group begins its 'Experimental Art Cycle' . . . October 7-19: Graciela Carnivale . . . a totally empty room, the window wall covered to provide a neutral ambiance, in which are gathered the people who

came to the opening, the door is hermetically sealed without the visitors being aware of it. The piece involved closing access and exits, and the unknown reactions of the visitors. After more than an hour, the 'prisoners' broke the glass window and escaped." The occupants of the empty gallery assumed the condition of art, became art objects, and rebelled against their status. In an hour there was a transference from the object (where's the art?) to subject (me). The artist's anger – and this is, I think, a hostile gesture – is switched to the audience's anger at the artist, which, according to the classic scenario of avant-garde transference, authenticates the artist's anger at the audience. Is this making too much of people being locked in a room and getting mad at the locker? The room in which they are locked is, if my information is correct, an art room. They were insulated by the great transformer. Locking people in a room without reason, with nothing in it, and giving no explanation, has, I would suggest, a sharper resonance in Argentina than in Soho.

Whole-gallery gestures came in a rush at the end of the '60s and continued sporadically through the '70s. The apotheosis of such gestures, in terms of scale and richness of readings, occurred in Chicago in January 1969. The subject was not the gallery but the institution that possesses not one but many galleries – the museum. Christo, a colleague of Klein and Arman in Paris around 1960, was asked by Jan van der Marck to do an exhibition at the new Museum of Contemporary Art in Chicago. Christo, who was doing a show for a nearby commercial gallery, suggested something special for the museum – the topological task of wrapping inside and out. The practical problems were formidable; these problems test the seriousness of a gesture, but they are usually forgotten – the inconvenience of being there is mislaid in time. The fire commissioner objected, but proved tractable. Mayor Richard Daley was an unseen presence. Following the 1968 Democratic National Convention, violence had been the subject of an exhibition at the Museum of Contemporary Art. This, the most successful political exhibition of the '60s, joined the board of trustees and the staff in the same posture of liberal outrage. (In addition, at the Richard

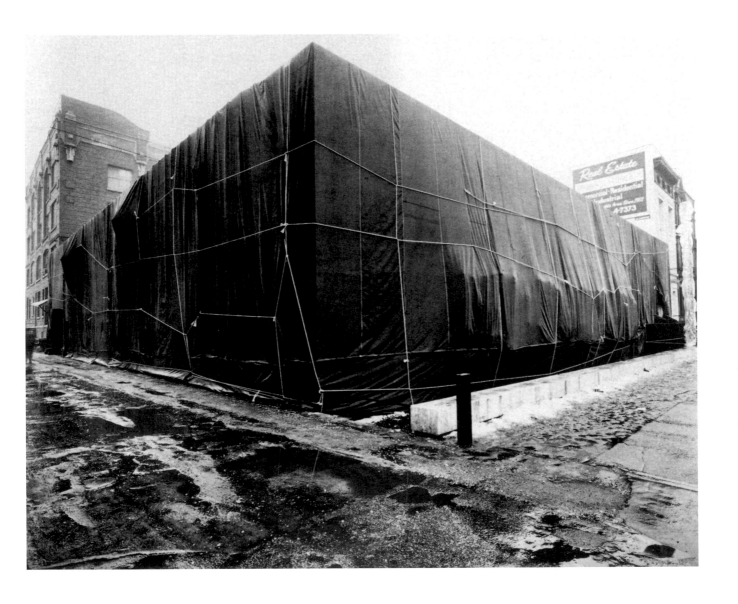

Christo and Jeanne-Claude, *Museum of Contemporary Art, Wrapped, Chicago,* 1969. 900 square meters (10,000 square feet) of tarpaulin and 1,100 meters (3,600 feet) of rope. ©Christo 1969. Photo: Harry Shunk. Reproduced by permission.

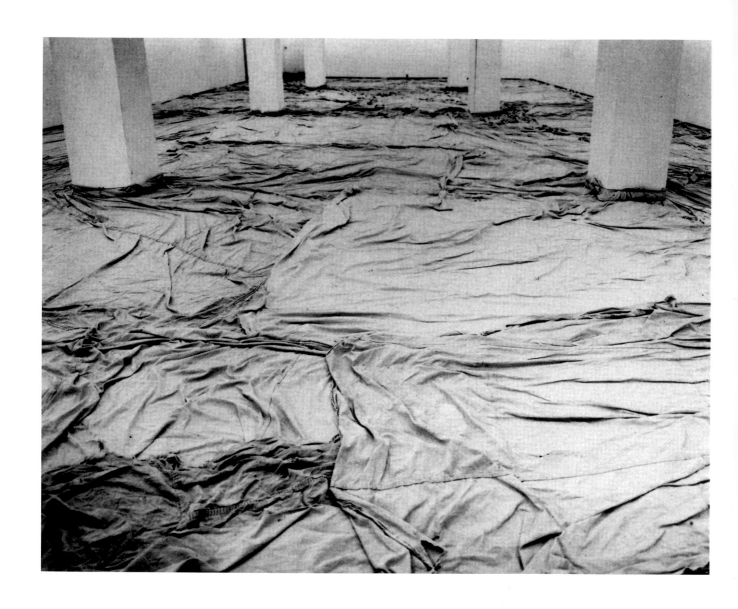

Christo and Jeanne-Claude, *Wrapped Floor and Stairway, Museum of Contemporary Art, Chicago,* 1969. 2800 square feet of drop cloth secured with ropes. ©Christo 1969. Photo: Harry Shunk. Reproduced by permission.

Feigen Gallery across the street, Daley was the subject of a savage artists' protest; notable among the works shown was Barnett Newman's *Lace Curtain for Mayor Daley*.) To everyone's surprise, the Christos' wrapping was accomplished without city harassment. The thinking is that the late mayor, once bitten by the national media, was content to let sleeping art lie. But what of the work itself?

Unquestionably, it was the period's most daring collaboration between an artist and a director. The only comparable occasion was the Hans Haacke/Edward Fry collaboration at the Guggenheim Museum in 1971. The museum was American, but the collaborators in Chicago were both European, one Dutch, the other Bulgarian. Van der Marck's tenure at the museum is now a fabled era, unmatched by that of any other curator of the '60s, with the possible exception of Elayne Varian's at Finch College in New York. Van der Marck became in part the co-creator of the work: offering the museum as a subject for examination was in perfect accord with modernist practice – to test the premises of every assumption and to subject them to argument. This is not the tradition of the American Curator, nor of his or her trustees.

Christo's wrappings are a kind of parody of the divine transformations of art. The object is possessed, but the possession is imperfect. The object is lost and mystified. Individuality of structure – the identifying morphology is replaced by a general soft outline, a synthesis that like most syntheses furthers the illusion of understanding. Let us confine ourselves to just a few gatherings from the harvest offered by The Wrapping of the Chicago MCA (process) or The Wrapped MCA (product). The museum, the container, is itself contained. Does this double positive, artifying the container that itself artifies, produce a negative? Is this an act of cancellation, discharging the accumulated content of the empty gallery?

The Christos' work presses esthetic issues to their social context, there to engage in political brokerage. A position must be taken not just by art folk but by the immediate public to whom art is usually as remote as the phyla in an aquarium. This is not a consequence of the work but its primary motivation. It is both avant-

garde (traditionally engagé) as well as post-modern (if the audience is fatigued, get another audience). It is also remarkable for the firmness of its ironies, which play for keeps – the loss of vast amounts of money, the one thing the public always understands. But what gives the work a political dimension – a closely reasoned argument with prevailing authority – is the way in which its process is conducted. The corporate structure is marvelously parodied: plans are made, environmental reports sought from experts, opposition is identified and met, energetic debate is accompanied by its share of democratic madness (public arguments on a local level bring out a free society's strangest mutants). All this is followed by the hard-hat technologies of installation, sometimes revealing the incompetence of various suppliers and of American know-how. Then the work is realized, to be quickly withdrawn as if its witnesses could bear no more than a glimpse of beauty.

These public works are of Robert Moses scale, but their awesome acquisitiveness is perpetrated with the most gentle, tolerant, and insistent grace. This combination of advanced esthetics, political subtlety, and corporate methods is confusing to the audience. Siting gigantic artworks in the midst of the body social is not a part of the American tradition. The Brooklyn Bridge had to be built before Hart Crane and Joseph Stella could get to work on it. Large-scale American art generally draws the Adamic artist to remote areas where transcendence is immanent. The Christos' projects mimic in scale the good works of government. They provide the useless at great expense. What they choose to wrap involves expenditures of such magnitude ($3.5 million for the *Running Fence*) that it seems irresponsible to those working on their heart attacks. Yet in the imperial tradition of Ayn Rand selfhood, they raise all the money through sale of the work. Despite such serious business, I am always surprised when sophisticated people think they are having fun. Some fun. Their projects are one of the very few successful attempts to press the rhetoric of much 20th century art to a conclusion. They force the utopian issue in the country that was once Utopia. In doing so they measure the distance between art's aspirations and society's permissions. Far from being the Russian dream

of an advanced art at home in an advanced society, they use the methods of an imperfect society and its myths of free enterprise to impose a will as powerful as that of any corporate board chairman's. Far from being folly, the Christos' projects are gigantic parables: subversive, beautiful, didactic.

The choice of the Modern Museum as a subject for wrapping was evidence of the Christos and van der Marck's deep seriousness; they sensed the malaise of an art often smothered by an institution that now tends to be, like the university, a corporate venture. It is often forgotten that the Christos, in wrapping the museum, was also symbolically wrapping a staff and its functions – the sales desk (that little repository of bricolage), the docents, the maintenance staff (blue-collar workers serving an alien faith), and also, by implication, the trustees. Paralysis of function also demanded that floor and stairs be wrapped, and so they were. Only the sensitized walls remained untouched. The nature of this wrapping has received little commentary. There was no neatness to it; it looked like an amateur job. Ropes and twine found notches to swing about, knots were vast and tied with thumbs. Slick packaging would make no comment on the American genius for such, which of course includes the packaging of people. So the Christos' packaged museum (explicit) and staff (implicit) proposes that containment is synonymous with understanding. With the museum packaged, is the way to understanding open?

Like all gestures, the project has an expectant quality, an openness that for satisfactory closure requires, like a question or a joke, a response. By definition, a gesture is made to "emphasize ideas, emotions, etc." and is "often . . . made only for effect." This deals with its immediate impact. For the gesture must snare attention or it will not preserve itself long enough to gather its content. But there is a hitch in a gesture's time, which is its real medium. Its content, as revealed by time and circumstance, may be out of register with its presenting form. So there is both an immediate and a remote effect, the first containing the latter, but imperfectly.

The presenting form has its problems. It must relate to an existing body of accepted ideas, and yet place itself outside them.

Initially, it tends to be perceived – or misperceived – somewhere on a spectrum from outright hostility to just fun. In this, the "art-like-ness" of the work is a liability. If it is perceived within an existing category, the category tries to digest it. Successful gestures – ones that survive their presenting form – usually abort the dialogue out of the accepted universe of discourse. In game-playing this is rule-modification. But in art the modification takes place over time and with uncertain – indeed unpredictable – results. Thus gestures have an element of charlatanry and fortune-telling. A bet is placed on an imperfectly perceived – but wished-for – future. Gestures are thus the most instinctive of artworks in that they do not proceed from full knowledge of what provokes them. Indeed, they are born out of a desire for knowledge, which time may make available. An artist's career (if artists have careers) cannot suffer from too many of them, for they jump it oddly about. A gesture is antiformal (against the agreement that art reside within its category) and it may be at odds with the smooth teleology of the rest of its perpe-trator's work. An artist cannot make a career of gestures unless, like On Karawa, his repeated gesture is his career.

The Christos' project is rare in that its presenting form and sub-sequent content are consonant, though of course the "fun" aspect was initially emphasized. The Christos' wit and humor are indu-bitable, but their complexities (laughter is not a simple subject) are far from fun. The project certainly negotiated a deeper understand-ing of a major theme of the '60s and '70s: the isolation, descrip-tion, and exposure of the structure through which art is passed, including what happens to it in the process. At this time the gallery received a lot of lip-service hostility, while being used by artists in that tolerance of their split-level existence necessary to survival. This, of course, is one of the marks of advanced art in the postcapi-talist matrix. Rendering to art the things that are art's and to the Collectors the things that they buy often happily coincide. Too much consciousness leads to embarrassment, the blush of the clos-et revolutionary. It is the particular glory of some '60s and '70s artists, including the Christos, that they met the implications of their own insights and polemics.

All these gestures recognize the gallery as an emptiness gravid with the content art once had. Coping with an idealized place that had preempted art's transforming graces gave rise to a variety of strategies. To those already mentioned – the death of metaphor, the growth of irony, the comedies of assigning value to the useless, "de-creation" – should be added destruction. Frustration is an explosive ingredient of late modernist art as options close off briskly in a converging corridor of doors and mirrors. A minor apocalypse forces itself upon us; it easily mistakes its dilemmas for the world's. Only two exhibitions formally acknowledged this free-floating anger. "Violence in Recent American Art" came from Chicago's Museum of Contemporary Art in 1968 under van der Marck; and Varian at Finch College, New York, put on a show of "Destruction Art", 1968, that the gallery spaces wrapped themselves rather uneasily around. No one trashed a museum, although alternative (to the museum) spaces took a beating. But various methods were used to reduce the placelessness and timelessness of the gallery's hysterical cell. Or the gallery itself could be removed and relocated to another place.

Afterword

Writing about your past writing is the closest you get to coming back from the dead. You assume a false superiority over your previous self, who did all the work. So, looking back at these articles, revived between their own pasteboards, what do I have to add? A great deal.

In the past ten years so much has been buried as if it never happened. Visual art does not progress by having a good memory. And New York is the locus of some radical forgetting. You can reinvent the past, suitably disguised, if no one remembers it. Thus is originality, that patented fetish of the self, defined.

What has been buried? One of the art community's conceivably noble efforts: the concerted move of a generation to question, through a matrix of styles, ideas, and quasi-movements, the context of its activity. Art used to be made for illusion; now it is made from illusions. In the sixties and seventies the attempt to dispense with illusions was dangerous and could not be tolerated for long. So the art industry has since devalued the effort. Illusions are back, contradictions tolerated, the art world's in its place and all's well with that world.

When the economics of a field are disturbed or subverted the value system becomes confused. The economic model in place for a hundred years in Europe and the Americas is *product*, filtered through galleries, offered to collectors and public institutions, written about in magazines partially supported by the galleries, and drifting towards the academic apparatus that stabilizes "history" – certifying, much as banks do, the holding of its major repository, the museum. History in art is, ultimately, worth money. Thus do we get not the art we deserve but the art we pay for. This comfortable system went virtually unquestioned by the key figure it is based upon: the artist.

The avant-garde artist's relation to his or her social context is made up of contradictions because visual art has a tin can tied to its tail. It makes *things*. And to switch Emerson around, man is in

the saddle and rides these things to the bank. The vicissitudes of this product, as it tacks from studio to museum, provoke occasional comment, usually of a vaguely Marxist kind. The idealism implicit in Marxism has little attraction for devoted empiricists, among whom I include myself. Every system construes human nature according to its desired ends, but ignoring the grubbier aspects of our nature, or disguising them, is every ideology's basic attraction. It sells us on the idea that we are better than we are. The varieties of capitalism at least recognize our basic selfishness: this is their strength. The comedies of ideology and the object (whether it be artwork, television set, washing machine) are played out on a field rampant with the usual false hopes, lies and megalomania.

Art is of course implicated in all of this, usually as an innocent bystander. No one is more innocent than the professional intellectual, who has never had to decide between two evils, and to whom compromise is synonymous with having his or her epaulettes torn off. It was the avant-garde that developed the self-protective idea that its product had a mystical and redeeming esthetic, social and moral value. This idea arose from the fusion of idealist philosophy's remnants with idealist social programs at the beginning of modernism. John Stuart Mills' *On Liberty* must be the ideal text to justify any avant-garde, whether of right or left, whether Futurist or Surrealist. But locating moral energy in a saleable object is like selling indulgences, and we know what reforms that provoked.

Whatever its heroic virtues, the avant-garde notion has, we now see, liabilities. Its peculiar relation to the bourgeoisie (first cited by Baudelaire in his preface to the Salon of 1846) is interdependent and ultimately parodic. The cult of originality, the determination of value, the economics of scarcity, of supply and demand, apply themselves with a particular poignancy to the visual arts. It is the only art in which the artist's death causes a profound economic shudder. The avant-garde artist's marginal social position and the slow move of his or her work, like some unmanned craft, to the centers of wealth and power perfectly suited the prevailing economic system. With any valuable product, the first task is to effect its separation from its maker. Modernism's social program, if one

can call it that, ignored its immediate context to call for large reforms on the basis that it spoke with a privileged voice. (This is the "fame" fallacy: ask Babe Ruth for solutions to the Great Depression.)

We now know that the maker has limited control over the content of his or her art. It is its *reception* that ultimately determines its content, and that content, as we see from revisionist scholarship, is frighteningly retroactive. The retroactive provision of content to art is now a cottage industry. And it is cumulative. Everyone must shoehorn-in his or her little bit of content. Nor has the original content, if we look at the history of modernism, any massive ideological effect. Modernism transformed *perception*, but the politics of perception remain unwritten. In the sixties and seventies, during the art community's dissent on Vietnam and Cambodia, a new insight took hold: the system through which the work of artists was passed had to be examined. This is a key marker, to my mind, of what is clumsily called postmodernism (is death post-life?) in visual art.

This was radical. Sometimes it's safer to sound off about large political matters than to clean up your own kitchen. Political courage is measured by the degree to which your position can, if prudently pursued, hurt you. It's less comfortable to begin the political process at home. Postwar American artists, with some exceptions (e.g. Stuart Davis and David Smith) had a poor understanding of the politics of art's reception. But several artists of the sixties and seventies, particularly those of the Minimal/Conceptual generation, understood very well. Their concern involved a curious transposition. Art's self-referential examination became, almost overnight, an examination of its social and economic context.

Several matters provoked this. Many artists were irritated by the audience available for art; it seemed numb to everything but, at best, connoisseurship. And the expensive compound (gallery, collector, auction house, museum) into which art inevitably was delivered muffled its voice. Art's internal development began to press against several conventional boundaries, inviting contextual readings. All was occurring in a restless social context in which

protest and radical formulations were an everyday presence. A potentially revolutionary situation existed. That quasi-revolution failed, as it had to. But some of its insights and lessons remain, though, as I said before, there is a vested interest in suppressing them.

It is an unanswered question – and will probably remain so – whether the art's responses to this situation were teleological or political. If the art work is the key unit of discourse, both esthetic and economic, therefore, the thinking then went, remove it. The system closes in a spasm around a vacuum. There is nothing or very little to buy, and "to buy" is, of course, the sacramental infinitive. Make the art difficult; that will hinder its assimilation. If art lives by criticism, make art more like criticism, turn it into words that make criticism itself an absurdity. And then have people pay for *that*. Examine the collector, including the provenance of his or her bank account; study what Nancy Hanks used to call the museum's greatest enemy: the trustee. Study the corporate drift of the museum and how the museum director, the most consistently persecuted member of the bourgeoisie, becomes a gypsy with a tie and a suit.

Study art's monetary fate, the protectionism that surrounds great investment. See the auction house at work, where the living artist may witness his or her authentication, but not partake in it. See the contradictions inherent in the place where art is shown and sold. And note the self-selection implicit in this system whereby the art of the museums is very different from what Cézanne talked about when he wanted to do over Impressionism. Just as formalism led to art made up by prescription (and just as the New Criticism used to generate its own poetic specimens), so museums have drawn forth a kind of museum art, to that degree an official art, appropriate for mass viewing. I would hesitate to counterpose a sinking landscape of good art that evades this process. But the thought that there is more here than our arrogance allows us to perceive remains troubling. And how do we explain the passion for the temporary that attempted to forestall the future? Above all, we were reminded, we must be aware of the

arbitrary and manipulative ways of assigning value.

What was the nature of this curious outburst of insight? Apart from the usual mild socialism, was it a desire to control the content of art by its producers? Or an attempt to separate art from its consumers? Part of this, intentional or not, was the break-up in the seventies of the mainstream into multiple styles, movements, activities. This pluralism was intolerable to esthetic purists, whose passion for a mainstream, however, assists marketing – not the first time that esthetic idealism and commerce superimpose perfectly.

The system also maintains its certainty of new product by a peculiar imperative I call "slotting," unique to the visual arts. Most artists become time-bound to the moment of their greatest contribution, and are not allowed out of it. The present rushes by, leaving them curating their investment – sad imperialists of the esthetic self. Nor is any change tolerated; change is considered a moral failure unless its morality can be convincingly demonstrated. Removed from contemporary discourse, such artists wait for random breezes from the present. Originality is reified; so is its creator. The art scene in any great center is always a necropolis of styles and artists, a columbarium visited and studied by critics, historians, and collectors.

What a grand irony that all this insight led, in the eighties, to a reconfirmation of all that had been laid bare and rejected. Product and consumption returned with a plethora of content for those starved of it. The new work's defense against smooth consumption is in its various masks, in which complex internal ironies are decipherable. Subject matter exploits itself, and some of the paradoxes of pop return, often serviced by a criticism that brilliantly questions the basis for value judgements. The gallery space has again become the unchallenged arena of discourse. But that is the subject of this book. Suffice it to say here that the elusive and dangerous art of the period between 1964 and 1976 is sinking, with its lessons, out of sight as, given the conditions or our culture, it must.

Brian O'Doherty
New York City 1986

Inside the White Cube *was designed by Jack W. Stauffacher of the Greenwood Press, San Francisco, California. Type is Méridien, designed by Adrian Frutiger. Text photocomposition by Kina Sullivan, San Francisco. Printed by Gardner Lithograph, Buena Park, California.*